HANG-UPS

HANG-UPS

Paintings by Jonathan Winters

Random House
New York

To all the young and old artists, painters, illustrators,
sculptors—who *can* draw a straight line.

Photography by Jonathan Winters and John Thomson

Copyright © 1988 by Jonathan Winters, Inc.
All rights reserved under International and Pan-American Copyright Conventions.
Published in the United States by Random House, Inc., New York, and simultaneously in
Canada by Random House of Canada Limited, Toronto.

Library of Congress Cataloging-in-Publication Data
Winters, Jonathan.
Hang-ups.
1. Winters, Jonathan. I. Title.
ND237.W774A4 1988 759.13 88-42664
ISBN 0-394-57024-3

Manufactured in Italy

9 8 7 6 5 4 3 2

First Edition

Design by Bernard Klein

Foreword

Jonathan Winters is widely known as a comedian. Everybody thinks of him as a funny man who does funny things. He sometimes dresses like an old lady selling dark brown garbage bags on TV with a mischievous look on his face. He talks softly at first. Then, all of the sudden, his humor hits you like an ax.

But I know Jonathan better. I enjoy seeing him as a performer and laugh at his jokes, but I also respect him and his work as a painter. I have visited his home and gone down to his nine-feet-below-ground studio in a four-by-four-foot room just big enough to hold a drawing table and a couple of chairs. We often sit there and talk about life, about art, and exchange ideas.

I have seen his paintings on exhibition, and his collection of interesting curios and knickknacks displayed in his house. His style of painting is abstract, reminding me of that of Wassily Kandinsky or Paul Klee at first sight. But his use of design, pattern, and calligraphy to express his feelings goes much deeper beneath the surface.

To understand his wonderful ability to tell funny stories as a performer, one must also see him as a painter and analyze his artwork.

–Dong Kingman

Introduction

In doing comedy, I've always had the most fun when I was improvising. And that's the way it has been with my art, too. All of my paintings come right out of my head, off the wall, thoughts that with the help of acrylics I've transferred to canvas.

Most of the time I go downstairs to my studio, turn on the radio (you've got to have music!) and let my mind wander. I let myself get lost; for me, painting has always been a great place to hide. Maybe that's because art gives you the chance to be an observer; you can lie low, become invisible, and imagine whatever you're watching turn into a painting. (Of course, you can't go around expecting to frame everything you see and hang it on the wall, but that's another story...)

Art has always been my passion, my very first love. This, despite the fact that I never received much encouragement for my efforts when I was a child. Granted, I wasn't any great shakes, but my stuff didn't even make the refrigerator! My parents just felt that painting was something no child of theirs should ever actually *do*. Maybe if I'd been better at it and had more style, I might have turned to art for a full-time living. My wife also reminds me that I probably would have starved.

After I came home from the Pacific after World War II, I did manage to spend four years at art school in Dayton, Ohio. Now, don't misunderstand me; school is terrific when it comes to giving students the tools they need. But I realize today that artists who are self-taught generally are more gifted (or get more gifted) than those with fancy degrees. The important thing school did for me was to open my eyes to all sorts of artists whom I've grown to love and who have influenced me. The French Impressionists–especially Manet, Renoir, Degas, and Gauguin–became favorites, and I'm still

fascinated by Salvador Dali's early work and the paintings of the great Belgian painter René Magritte. And then there were all the great Americans! Andrew Wyeth, Edward Hopper, Reginald Marsh, Thomas Hart Benton, Frederic Remington, Charles Russell, James J. Audubon, Kevin Red Star, my friend Dong Kingman and many, many more.

It's a pretty eclectic group, but maybe that's because the work I like, or the work I do, won't fit into any easy mold. The best label I might use for myself is–well, I can't really think of a label. I guess you might say I'm a combination of a primitive painter and a Surrealist. The added ingredient is that from time to time I use my pictures to make statements about the things that concern me–war, animal preservation, the fate of America's Indians, religion, death, life.... Which doesn't mean I try to be political or anything like that. Because most of the time when I paint, I just paint.

Why? Because when I do, it's one of the few times I feel completely relaxed. When I don't feel under the gun. When I feel totally in charge, that I'll sink or swim with whatever I've put down on that piece of canvas. And that's the way it should be. Paint for yourself, and if you don't hate it so much that you've got to turn it to the wall, it makes you feel wonderful. Be prepared for rejection–not just in art but also in life–because there's lots of rejection. And don't fall in love with everything you make–remember, if it sells, it's a bonus; years ago, when I sold my one and only cartoon to the old *Saturday Evening Post*, it was my biggest thrill. Until this book, of course.

So listen to my advice. Find a chair, a kitchen table, an old drafting board, a little loft with north light, a dozen tubes of paint, some brushes and, yes, don't forget that radio–and go to work.

I hope you'll enjoy my paintings as much as I've enjoyed making them, and as much as you'll enjoy painting your own.

–Jonathan Winters, May 1988

HANG-UPS

The Umbrella Dancers

I've had a great response to this painting over the years, and the reason why, I think, is that it's basically so darn simple. Sort of like the act of painting itself–especially when you compare it to making television shows or movies, where there's a director, a producer, an executive producer, writers, a film editor, and God knows who else. It's like having an army of people coming in and changing your work. But with painting, you do exactly what you want to do. No censors, no filters, just you. And that's a good thing, the best.

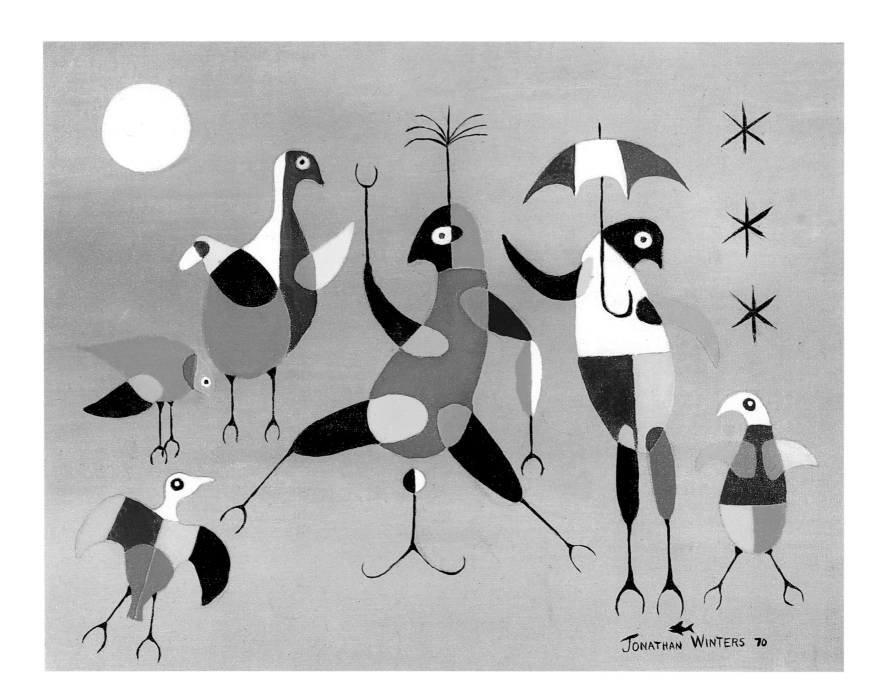

The Beginning of the End

The full moon has an important effect not only on the tides but also on people's minds. So I often paint full moons because when they appear I know a lot of us—myself included—are a little crazier than we'd otherwise be. As for the cross, well, maybe the pull of the moon is so strong it can lift the dead right out of their graves.

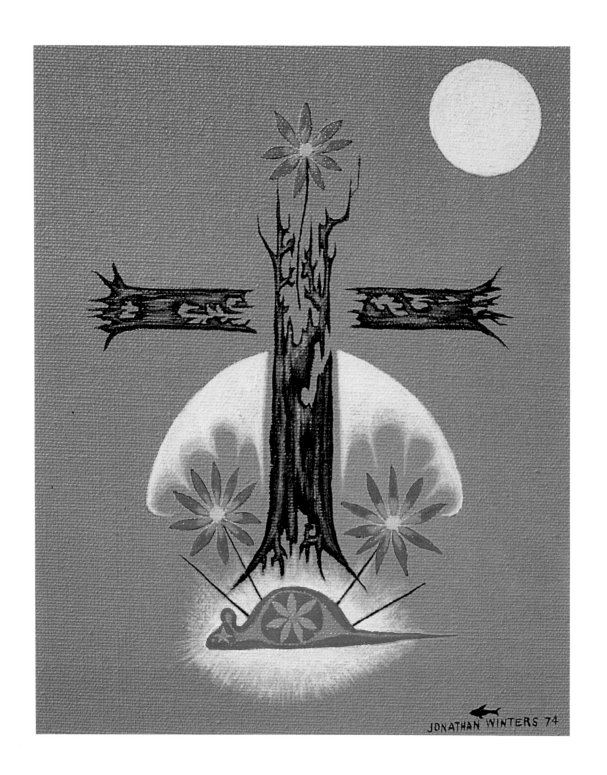

Pathetic Black Moon with Awful Vase
with Dead Flowers in It

Exactly what it says, and a put-on. I wanted to see if someone would buy it, and you know what? Someone did. It reminds me of something I heard about the Museum of Modern Art in New York, when they acquired some huge canvas that was white except for a little red dot in the center. I think it was called "Titanium White with Dot" and it set them back about two hundred grand. Which is, to me, very scary indeed.

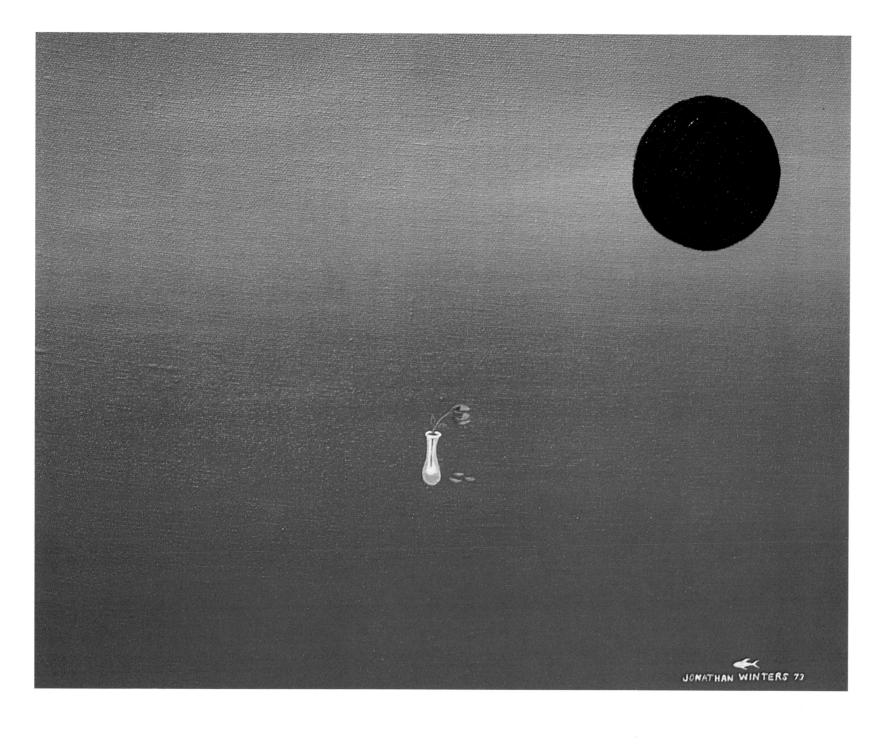

Birds With Bent Beaks

The reason I did this is that you obviously don't see a whole lot of birds with bent beaks in real life. So I made them up—just my idea of humor. Sort of like the hangers here and in many of my other pictures. I use them because of the term "hang-ups"—that's what they mean when I paint them. As for me, I don't really have any hang-ups—except that there are probably fifty well-known artists I just wish I could paint as well as.

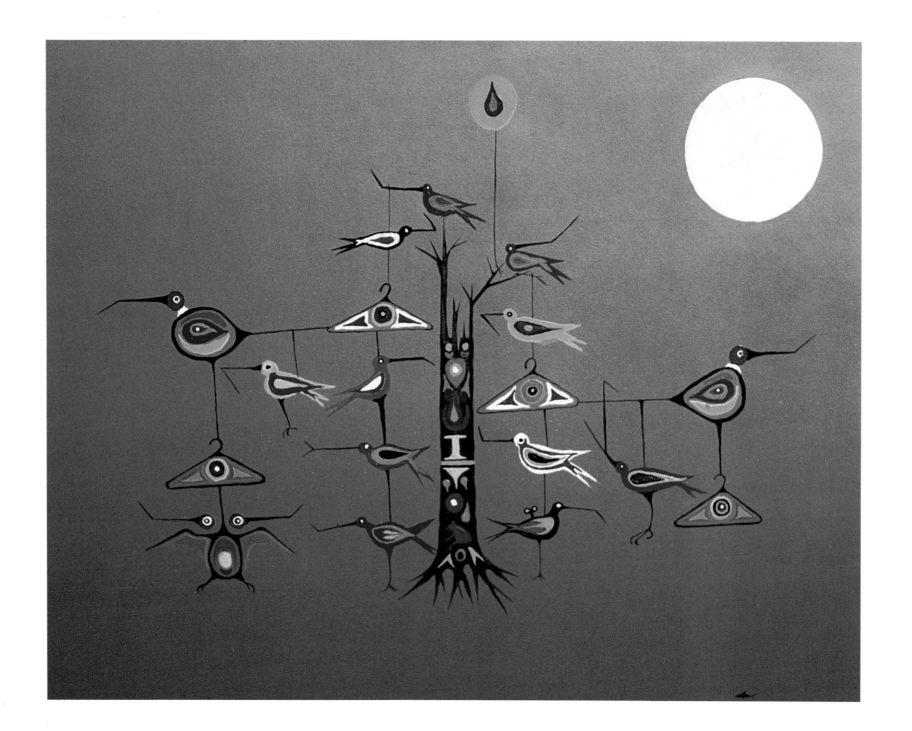

Ants Eating Corn

When I was a little boy growing up on a farm in Ohio, we had tomatoes, cucumbers, chickens and cows all around us. There were also rows of wheat and, of course, acres of corn. Come late August, we'd go out in the fields, ready to shuck ears of golden bantam, which always tasted so good to me. I guess what wasn't so good was the ants, thousands of them, running off with the kernels. If the raccoons didn't get the corn, I guess something else had to, anyway.

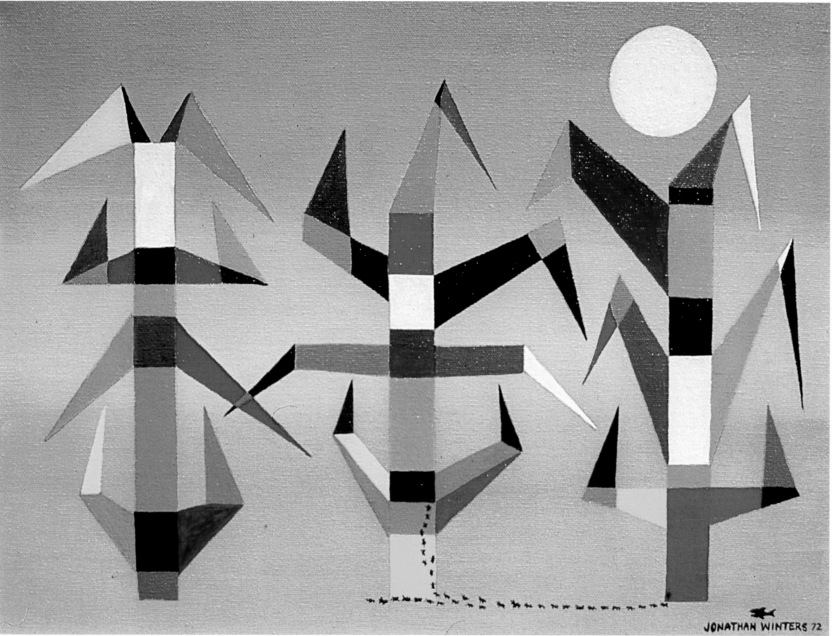

An Evil Woodpecker

I was sitting at my drawing board one day and simply had a flash of thought: Wouldn't it be something to see a woodpecker chipping away at a wooden cross? I mean, if a woodpecker found a crucifix or a Star of David with some termites, he'd just go for them, right? No hesitation, and you can't blame the woodpecker. So why is he "evil"? Probably just my Protestant background...

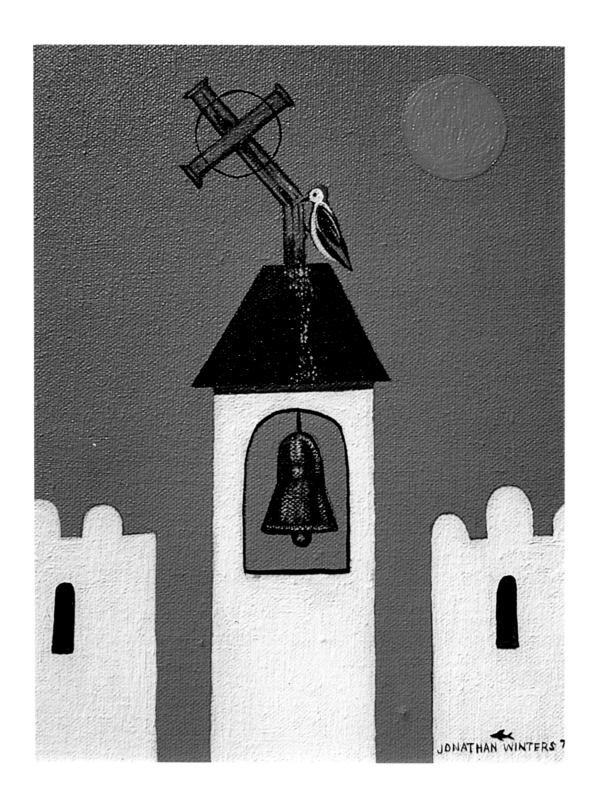

The Thoughts of a Matador

There's a lot going on here, a whole lot. I went to a handful of bullfights during the late fifties, and what impressed me most is what precarious, tragic, frightening lives matadors lead. And as you can see, this matador is literally disintegrating right into the picture. (If you did for a living what a matador does, you might disintegrate, too.) The birds, by the way, represent freedom, the black moon spells death, and the fish—I'm just assuming that this matador, like most matadors, is a Spanish Catholic. Oh, one last thing. The number 11? It's just because it's my lucky number, as in November 11—Armistice Day *and* my birthday.

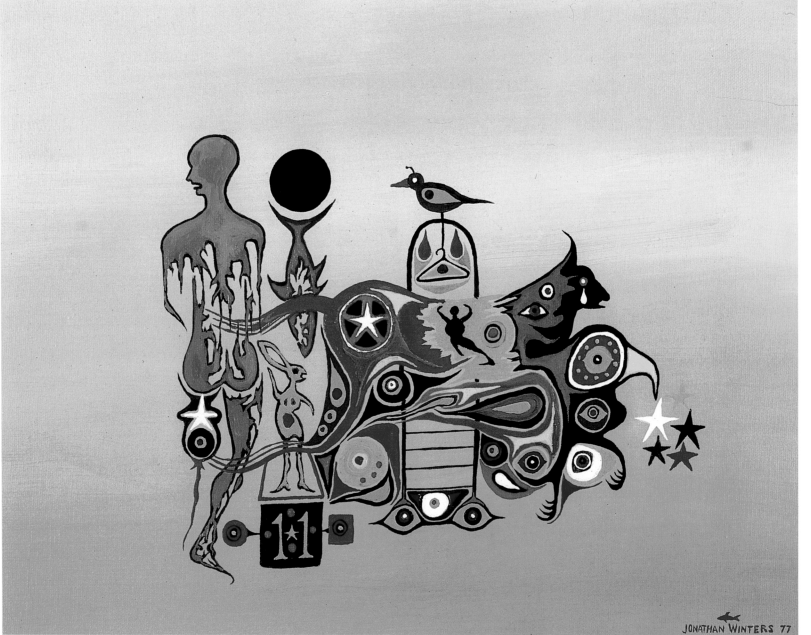

Three Birds Looking at a Holy Bird

I have absolutely no idea what this picture is all about. Just some ideas that flashed through my mind and I transferred to canvas.

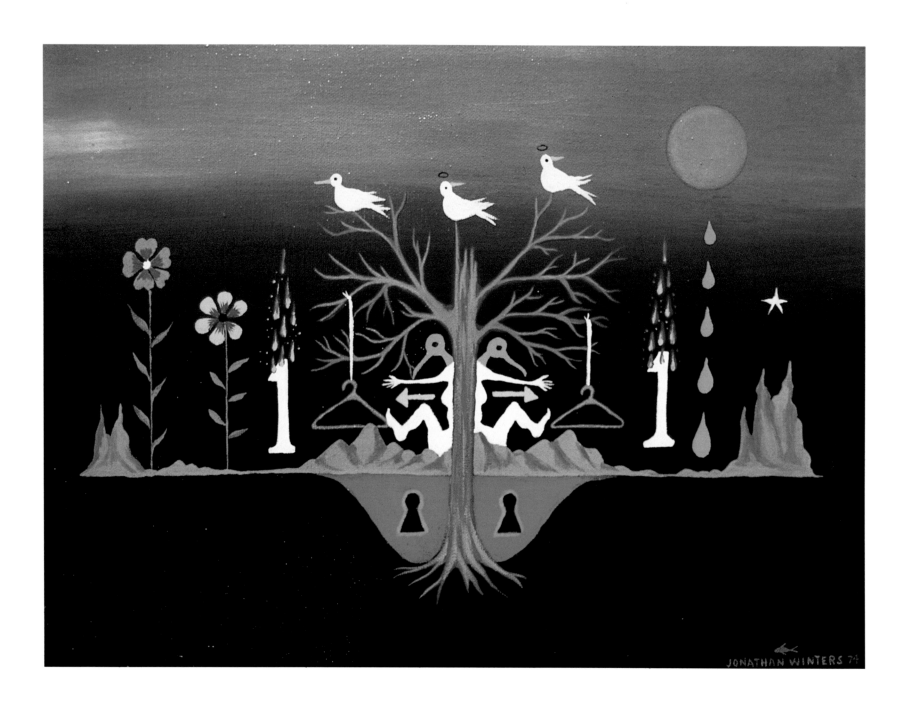

Crazy Old Lady at the Beach with Sunburned Boobs

A few years back, when I was pulling together my paintings for a gallery show, I turned to my wife and asked, "Eileen, do you think I should include this one?" And she answered, "Put it back. It's not very good, I don't like the subject matter, and the best thing you can do is paint over it." Well, maybe because it amused me, maybe because of ego, I decided to ignore her advice (for the first time) and take a chance. And you know what happened? Alice Cooper, the rock 'n' roll star, saw it, loved it at first sight, and bought it that very day. The moral, I suppose, is Don't be afraid of sunburned boobs and never throw anything away.

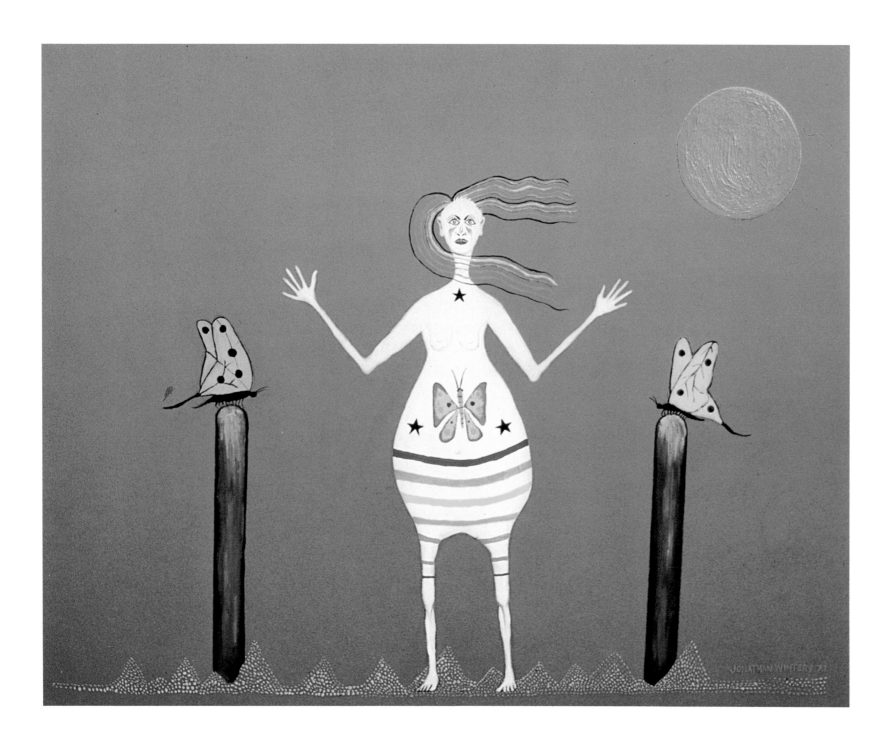

When I was a kid, playing cowboys and Indians, it wasn't very popular to want to be an Indian. But that's what I wanted, and in fact, though I'm already one-sixteenth Cherokee, there's nothing that would have made me happier than to be a full-blooded Indian.

A big reason is that with Indians I've always felt there's a great peace. Exactly what that peace is I can't put a finger on, but their knowledge of, as they say, Mother Earth, Father Sky and the Great Beyond extends to places we can never see, to frequencies we can't hear. We've stripped the Indian of so many things, we have taken their land, stolen their heritage. He has lost so much, but he has never lost who he is. And that's why I paint the Indian in his strength and his colors.

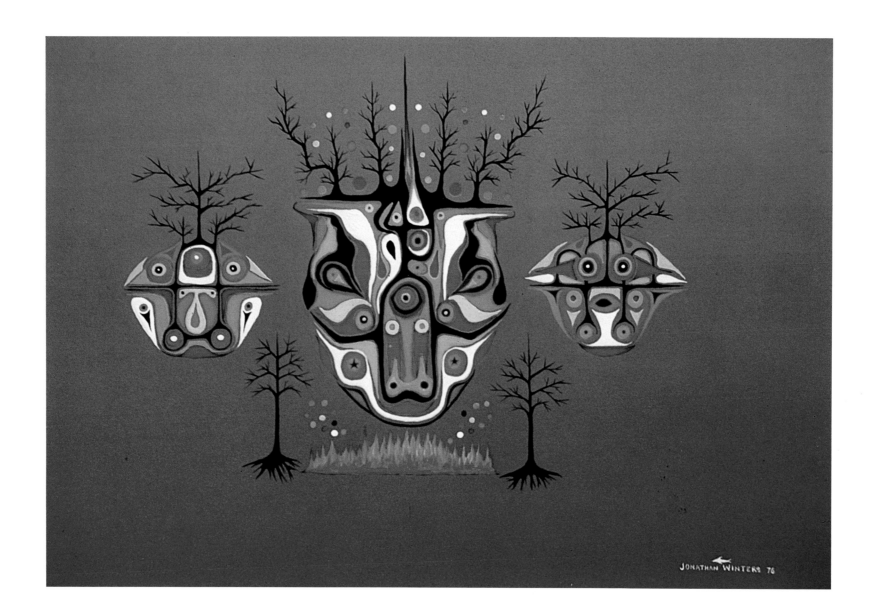

Little Bird with Big Birds in the Daisies

I have to confess that there haven't been many times when I've actually seen a bunch of birds in a field of daisies—and that's probably why I made this picture. But what I have always seen, wherever I look, is one little bird. Some tiny guy wondering what the heck it's all about, and "Why, oh why, was I born? What am I doing here with all these big birds?" He's an outcast, you see, hoping to God he grows up like the rest of the birds around him. And, you know, he's always a bit scared. Who can blame him?

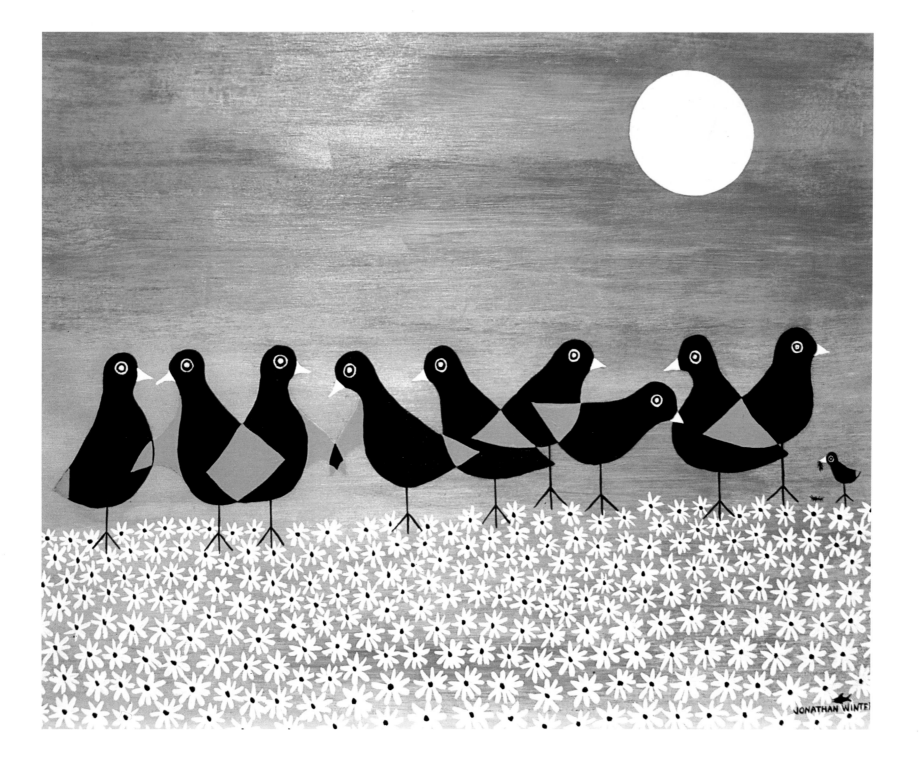

Hollywood Pool Man

He's the guy who puts some chic chemicals in your pool, and if there's a lady of the house, the Hollywood Pool Man always shows up in the late afternoon. For some reason or other.

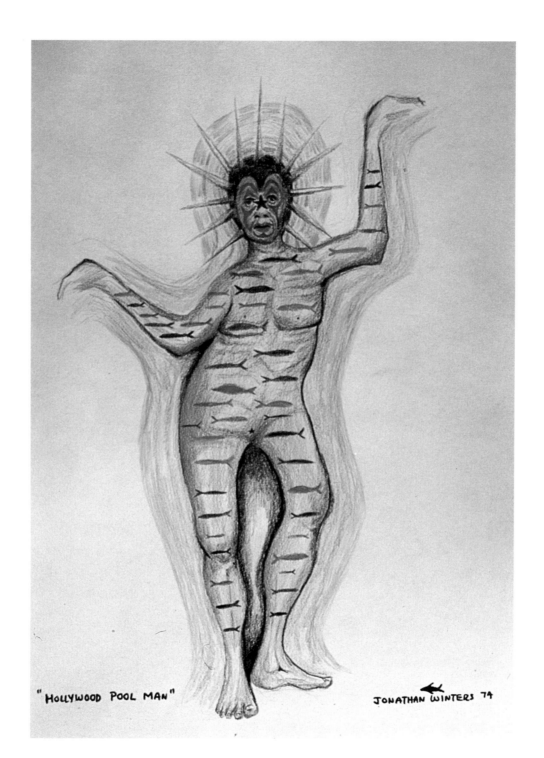

"HOLLYWOOD POOL MAN" JONATHAN WINTERS 74

The Firebeast

There's nothing quite as ferocious or as frightening as a fire burning its way through the woods. Where I have a little home, near Santa Barbara, there are often enormous forest fires, sucking down everything in their paths, consuming the woodlands, scaring any living thing. They make you feel small, insignificant, helpless, and, at the same time, in awe of the power of fire.

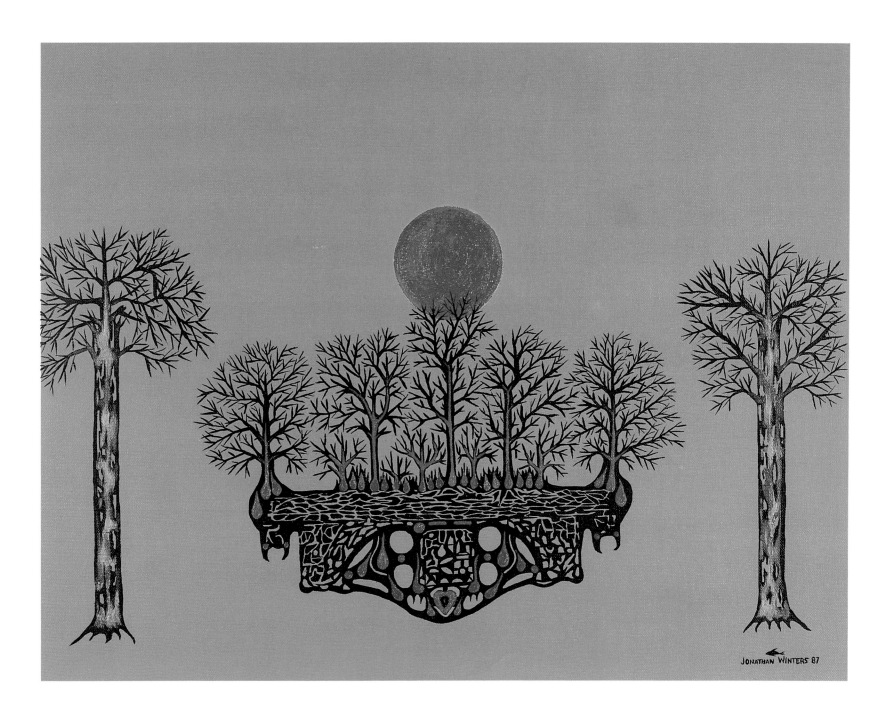

I want to believe there's *something* out there, like sea serpents or even UFOs. Who's to say? So, from time to time, you'll hear about the Loch Ness monster, which is seen, also from time to time, in northern Scotland. I've always thought that if anybody could find that monster, and make believers of us all, it would have to be Monsieur Cousteau.

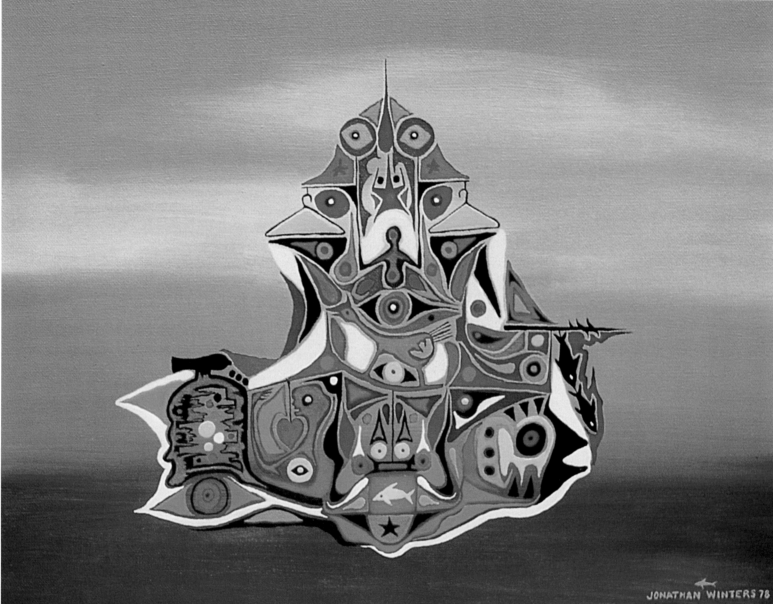

Forbidden Fruit

What's my idea of forbidden fruit? The notion that if you were to partake of this apple, it just might be poisonous and you'd die. Which is another reason why the old cliché about an apple a day keeping the doctor away may be true.

The barbed wire just reinforces the concept. Who knows, maybe it's electrified? And if you reach for the fruit, the apple will stay red, but you might not be seen at all.

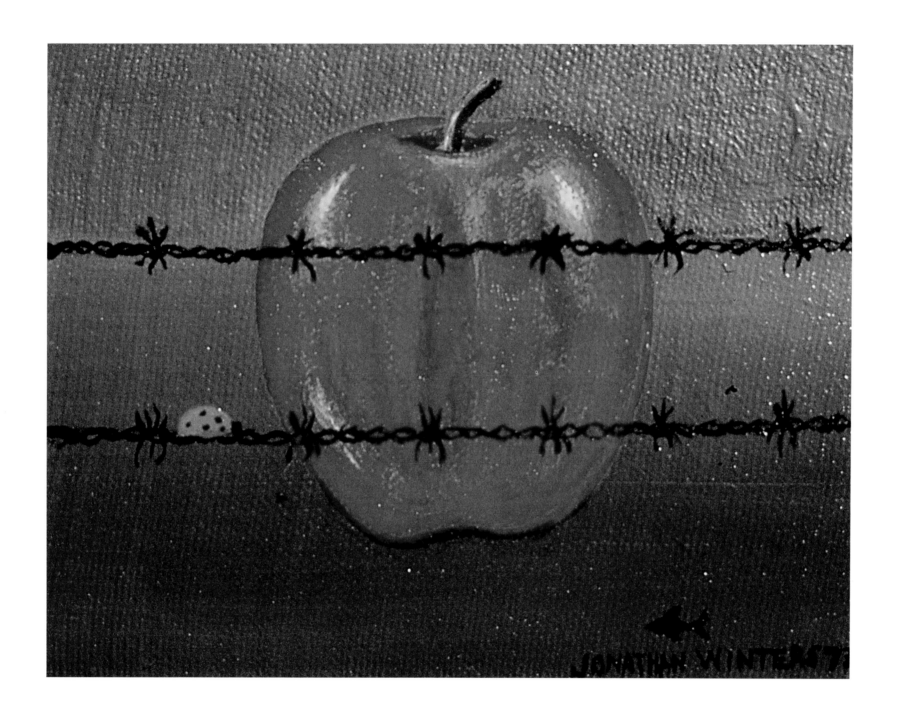

A Light in the Attic

I always loved going into Grandmother Winters' attic in Dayton, Ohio. It was the size of a ballroom, chock-full of antiques and furniture, all covered with sheets to keep out the dust. So when I was a kid, I'd go through everything she collected, from spinning wheels to early flags to Indian gloves. There was even a Civil War sword that some relative had probably carried in a parade. But the real reason for being there was to hide. Which wasn't hard, considering how dark it was. And like all attics, there never was a convenient way of switching on the light–there was just one naked bulb in the center with a long heavy cord that you approached blindly while tripping over a steamer trunk. I'm sure you know just what I mean.

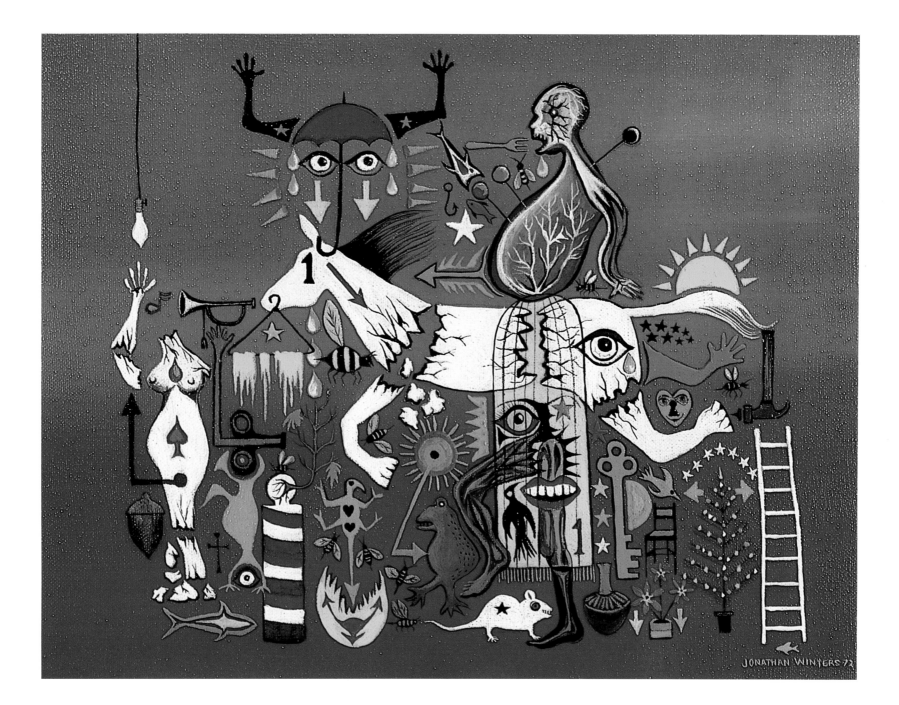

Crows in the Cornfield

The eagle may be our national bird, but if there's ever a creature that will never make it to the endangered-species list, it's the crow. You've got to admire crows for that, if for nothing else. I don't know about you, by the way, but I love golden bantam corn–just like the crows.

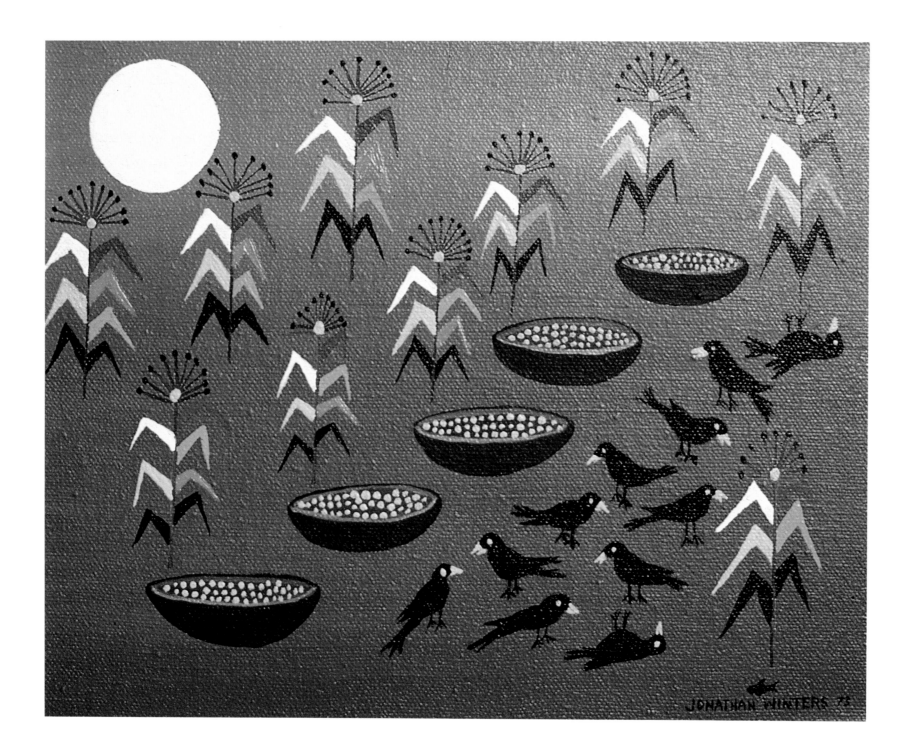

Watergate, 1973

In my version you'll see ladybugs bugging the phone. Of course. But what got to me about Watergate was this: As Americans, we consider ourselves the most honest people on the face of the earth–the leaders of the free world and all that, with a lot to live up to. And then, when our politicians get caught doing something wrong, we say, "Gosh, I didn't expect that of him!" There's not a whole lot of reality going on. Especially when we're discussing politicians, who tend not only to be sleazebags, but, shall we say, odd fellows.

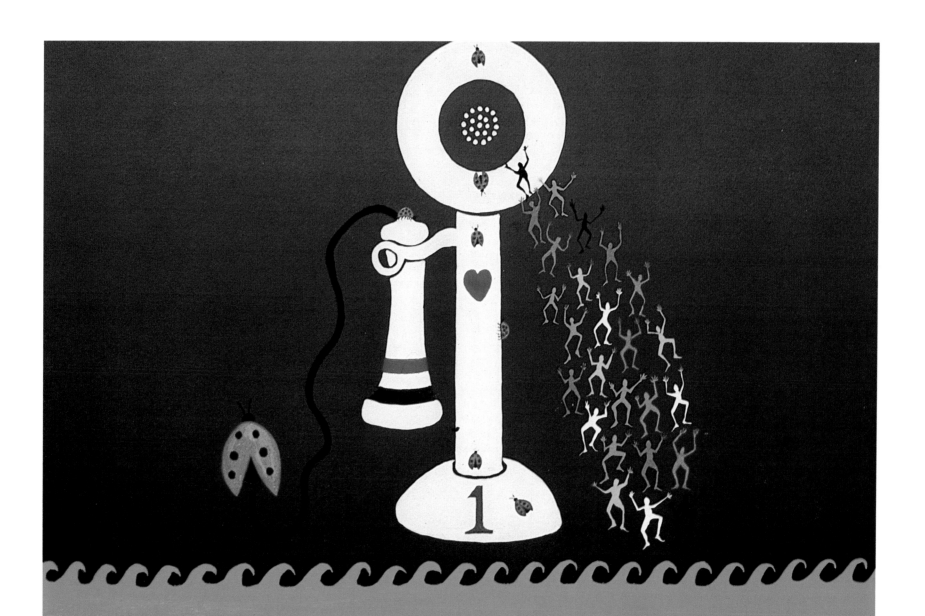

Kamikaze

During World War II, I served in the Pacific on the aircraft carrier USS *Bonhomie Richard*–CU-31. And I managed to live through a kamikaze attack, in which one plane just barely missed blowing us up–its tail piece hit the forward elevator on the port. But before it made contact it was so close, I saw the pilot's face; I can't forget it to this day.

The kamikaze pilots were fascinating to me; many were intellectuals, religious and political fanatics who believed that if they died in this sacrificial manner, they'd get to heaven right away. *My* attitude was: I'd rather wait.

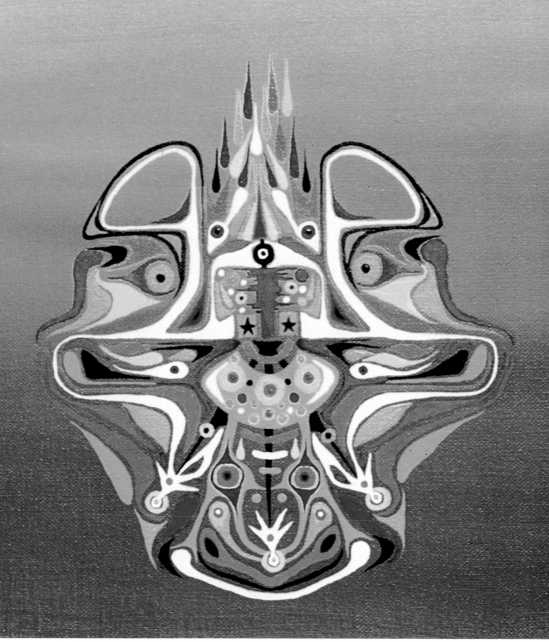

All-American Dead Tree

Just as people bring America to life, the birds bring this tree alive. I'm not, of course, saying this country is dead or anything, only that what keeps things rolling, and hopeful, is the vitality of those of us who remain.

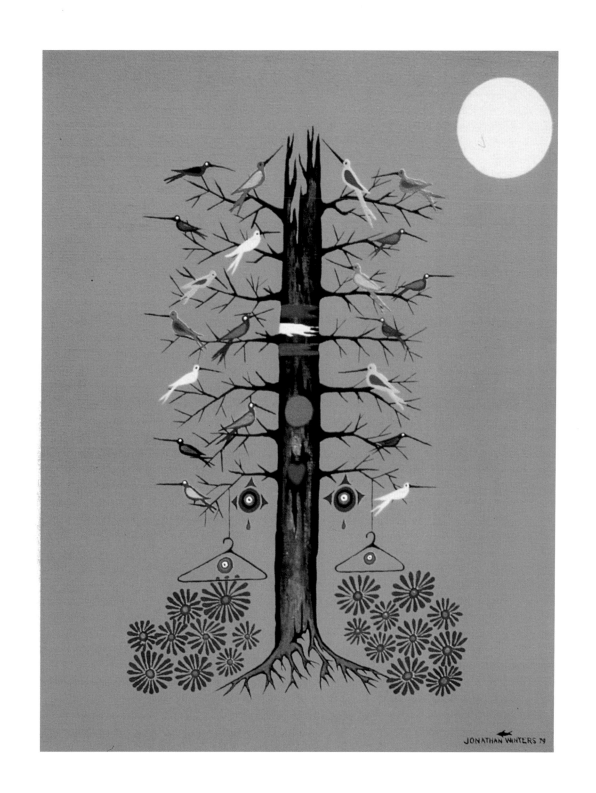

The Indian and the Animal in the Happy Hunting Grounds

The title says it all, except that the images here came to me as so many of them do—in daydreams. I close my eyes and let my mind just wander. To me, it's as interesting (and important) as the dreaming we do at night.

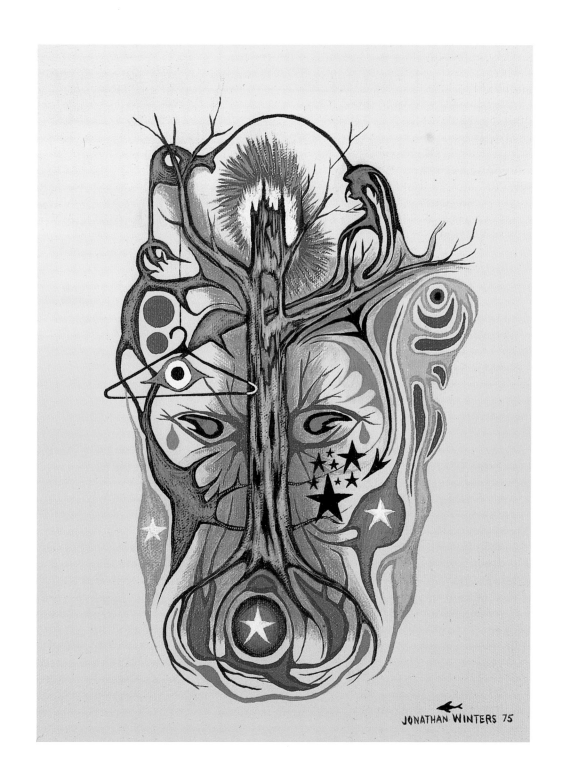

JONATHAN WINTERS 75

The Survivors

I classify myself as a survivor, a survivor of a lot of things. I overcame alcohol. I overcame smoking. I overcame chocolate ice cream. Now I know many people have bigger problems, and I have some myself. But for anyone who has survived I have great admiration. Just going through life itself is surviving. Just going crosstown.

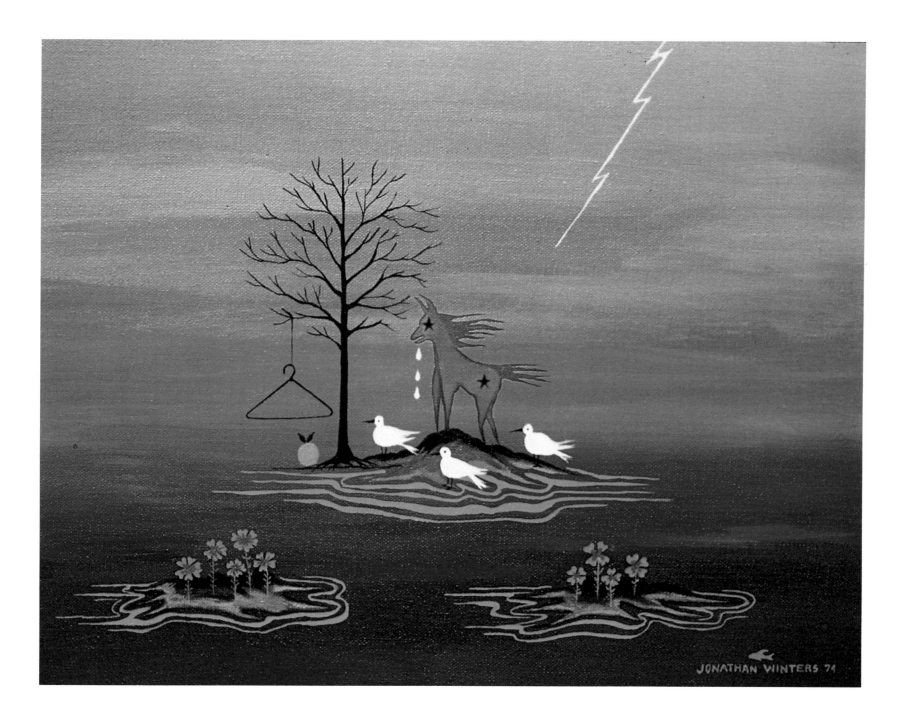

JONATHAN WINTERS 74

Birds on a Snowy Day

I don't know if I really remember seeing birds running through the snow, but what I'll always remember growing up were the millions–okay, maybe hundreds–of tiny footprints they left behind. And this painting is as simple as that.

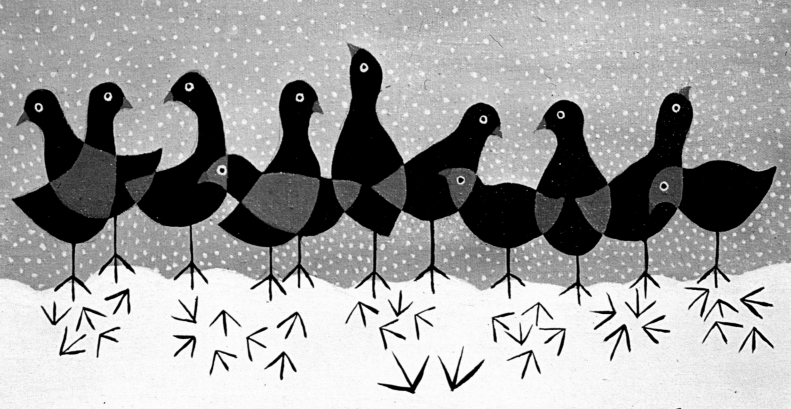

The Hang Gliders

They fascinate me. I go out to the Pacific Coast Highway, or inland to the Sierra, and watch these guys and gals just soar. Once in New Zealand we went to a spot about 8000 feet up and watched a kid get rigged up, with all the lines and belts, and just get shoved off a cliff and fly. He had on this weird outfit and he looked like Batman. For someone who loves birds as much as I do, maybe people who fly on the hang gliders make me a little jealous. But then again, there's no way I'm going to try that.

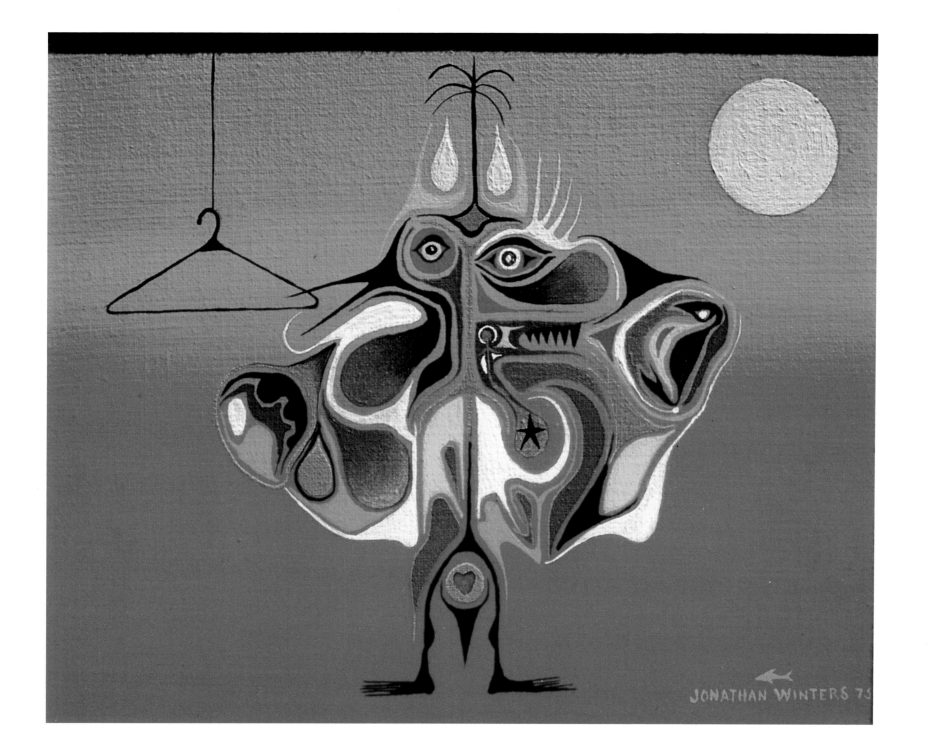

JONATHAN WINTERS 75

A New Member

I always thought the Ku Klux Klan was as frightening a movement as there's ever been in this country. And that's why I felt it might behoove them, someplace along the line, to have a black join up. Maybe it would shake things up.... No matter, I think every movement needs a new member.

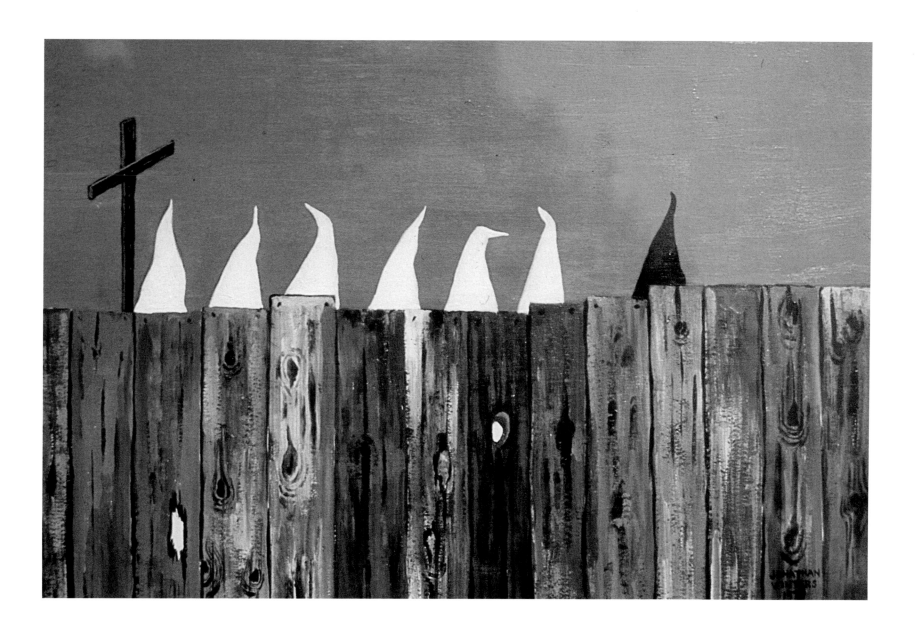

Three Bluebirds Full of Marbles

They could've been full of other things, and I can't for the life of me tell you why I put the marbles there. But then, why not? I might add you don't have to be in a tournament to lose your marbles.

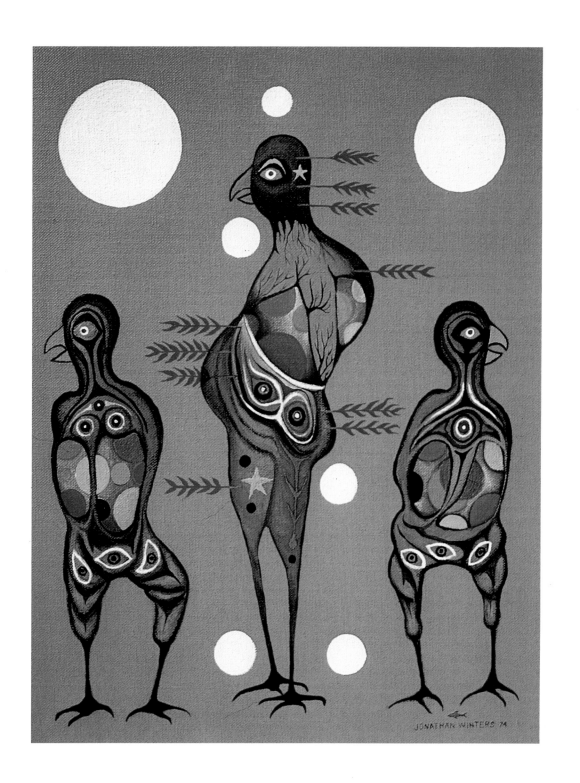

Northwest Whale

To me, a whale is as good a good-luck charm as a four-leaf clover. There's nothing like being at sea and watching them swim alongside your boat–powerful, friendly, frightening and fast. I've only been whale watching a couple of times, but let me tell you, seeing them is a thrill that no one can either forget or deny themselves.

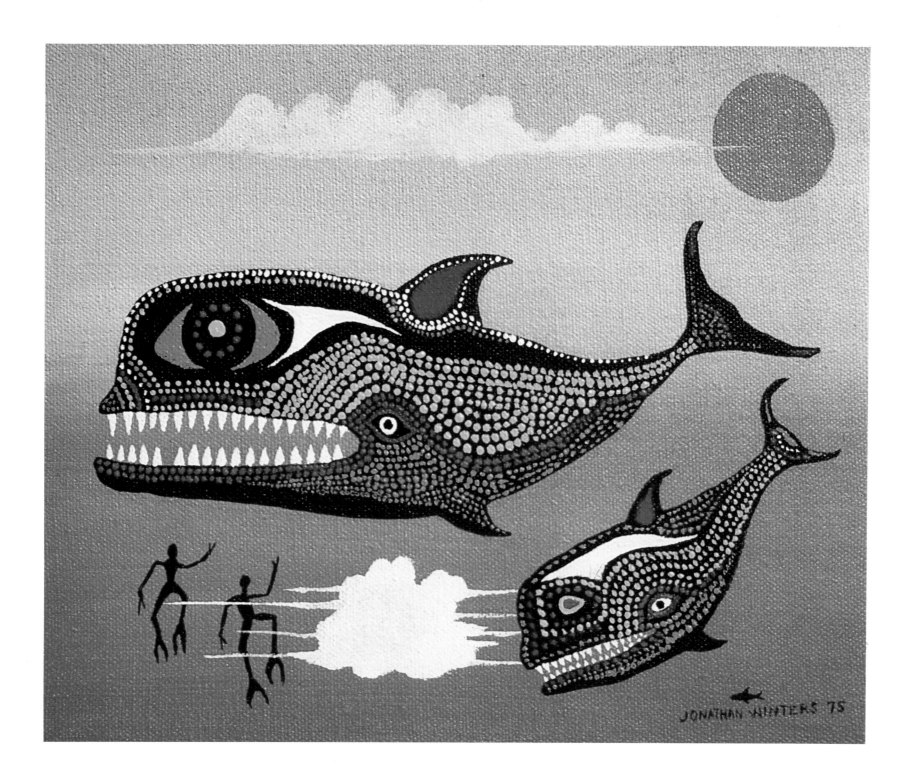

Urban Renewal

Even though urban renewal was a gallant idea, it still hasn't worked for the poor. Slums are still slums, gutted and ruined, and con artists still exploit the people who live in those ghettos. They try to convince everyone there are bargains, but the only things that are really half-price are items that cost too much money no matter how cheaply they're sold.

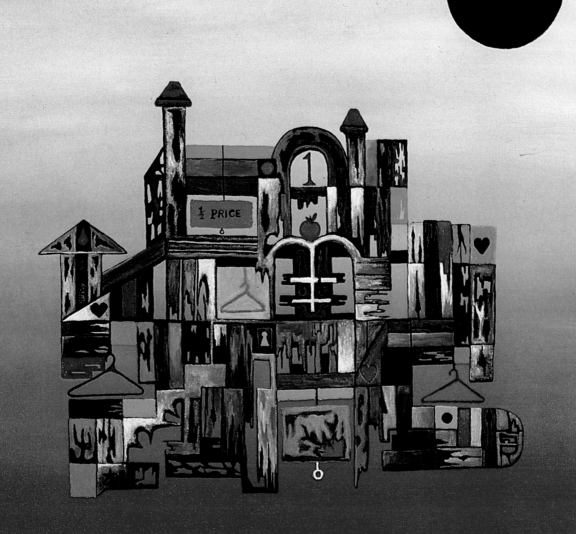

The Corn Dancers

I've visited various Indian reservations. The Navajo in Arizona and New Mexico. The Chippewa up in Minnesota. The Black Foot in Montana. All over the country. I have a deep affinity for the Indians, for their great people and their art. I've borrowed from some of their styles, and you'll see traces of them, affectionately rendered, in my work.

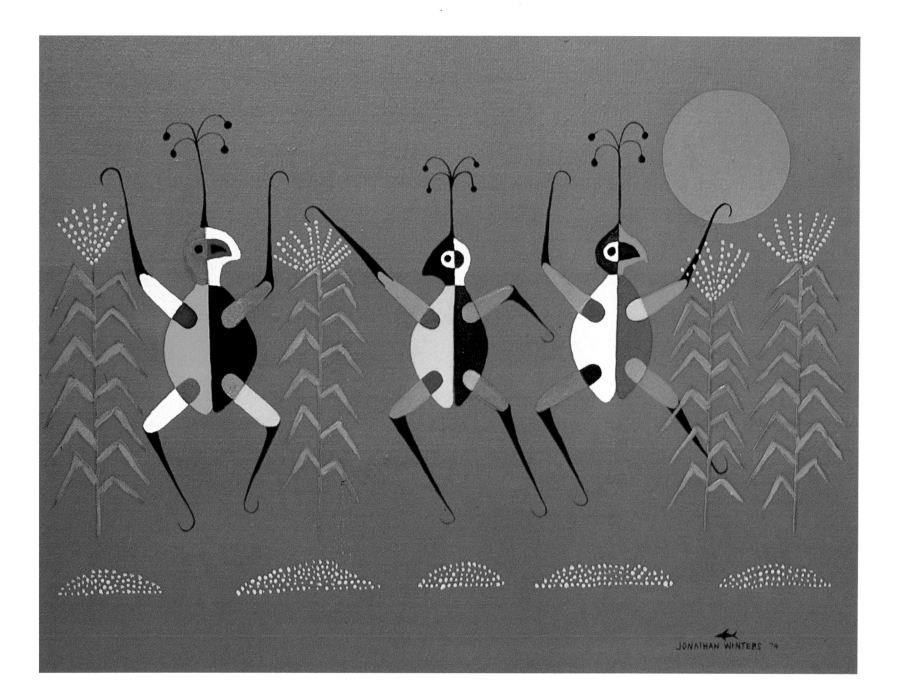

Hummingbird with Three Eggs

If one has some semblance of faith in some sort of Supreme Being, the hummingbird is a good reason to make one go over the edge into belief. He's so tiny, with so many brilliant colors, and what does he do? This little guy covers three hundred backyards in about twenty minutes! If I actually tried to put together a real picture of a hummingbird, he moves so fast there'd be nothing there.

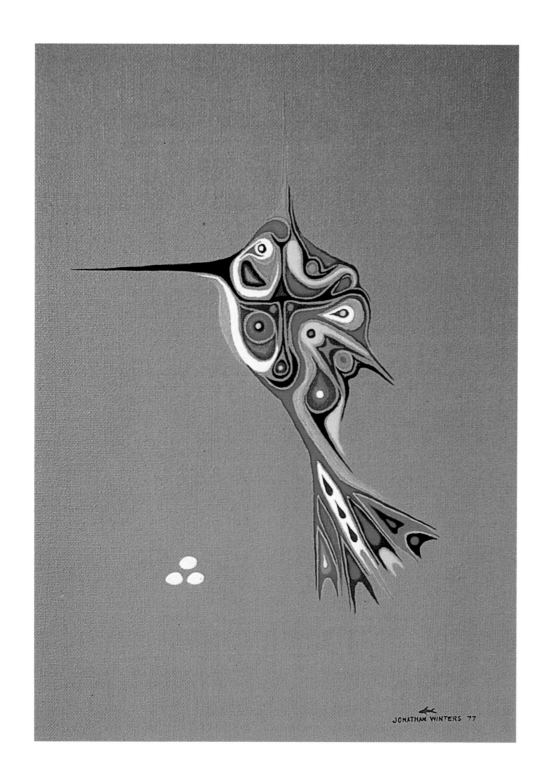

Hung Up on Something Big

I don't hunt, but I do love to fish. I've been especially fond of deep-sea fishing—in Bermuda or off South America—but I have such strong feelings about what the commercial fishermen are doing, scooping up all those game fish while trying to get tuna, that as a bit of protest I've put my deep-sea gear away and turned to fresh water. Now, I take only what I'm going to eat and release everything else. That is, *if* I catch anything at all. You know that expression "Hey, you're hung up on something big down there?" Well, even when you think it's a big one, it usually turns out you've caught an old Goodyear. And to make it worse, there's a full moon. You've been casting all day, getting nothing. So at night, you're popping a couple of cool ones in a funny log cabin with the beer boys, fire crackling, and while all that's going on, the fish are finally up there, feeding like maniacs. Why? Because that Big White Number's up there in the sky.

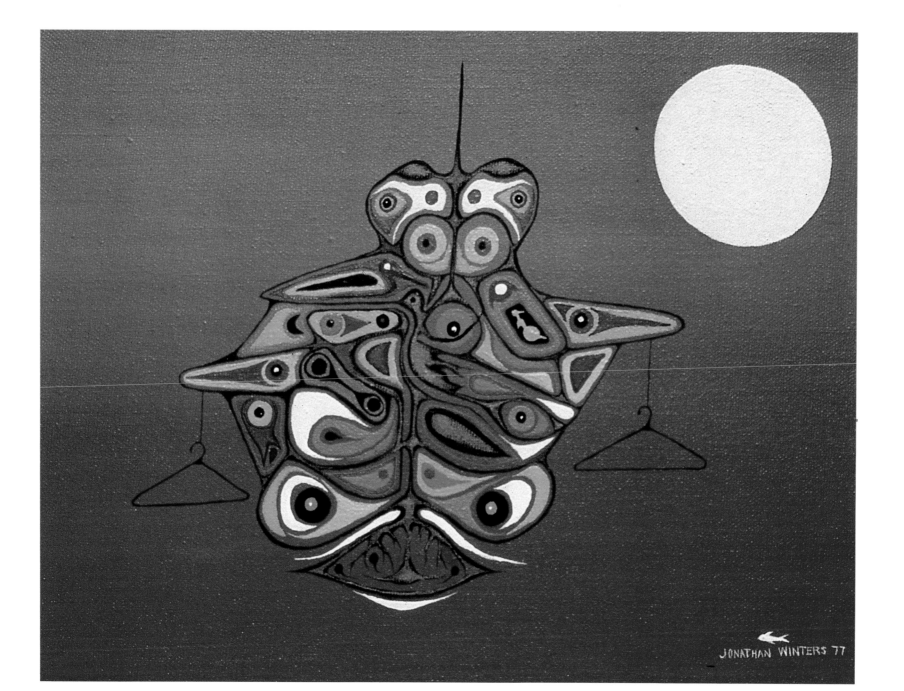

Wounded Knee

This was the opportunity for me to really put down on canvas many of the things I felt strongly about concerning the plight of the Indians. I was very moved by the Wounded Knee incident a few years back, when protesting Indians took hostages in the Dakotas, leading to a violent confrontation. In defense of the Indians, the barbed wire typifies the way the Indians have been shut out of society. I've never been sure that what the Indians did at Wounded Knee was justified–I've never condoned force–but I think I understand the frustration. Especially when you consider that Indians have always been more givers than takers.

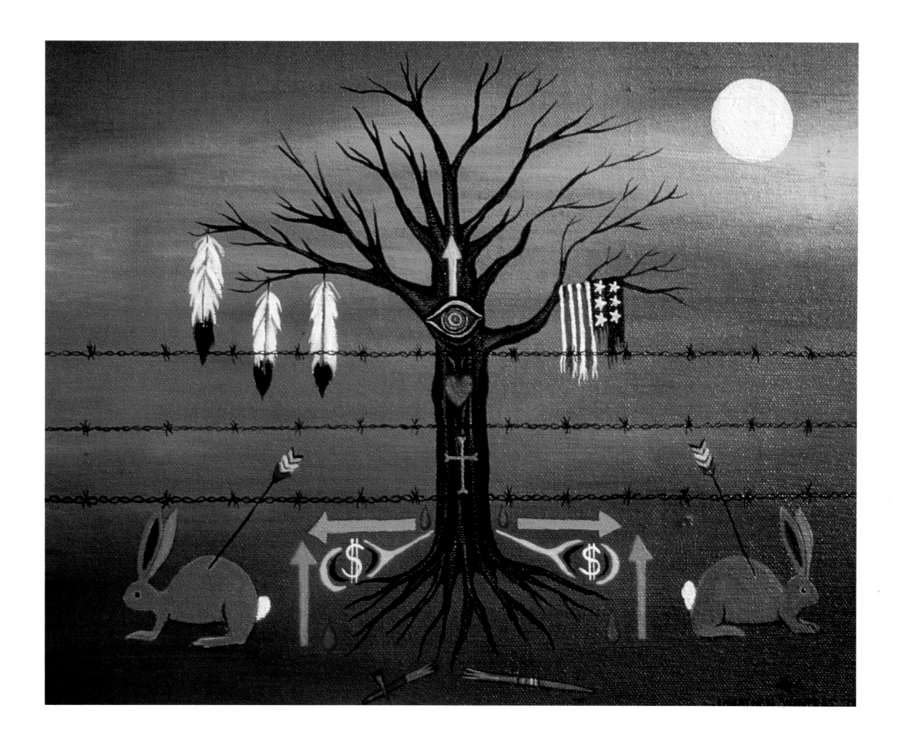

Storm over America

We have red, white and blue umbrellas, standing for this nation, and other colored ones for all the different ethnic and racial elements. It's not a heavy message, really a quiet one, hoping we protect ourselves from the dangers we cause one another.

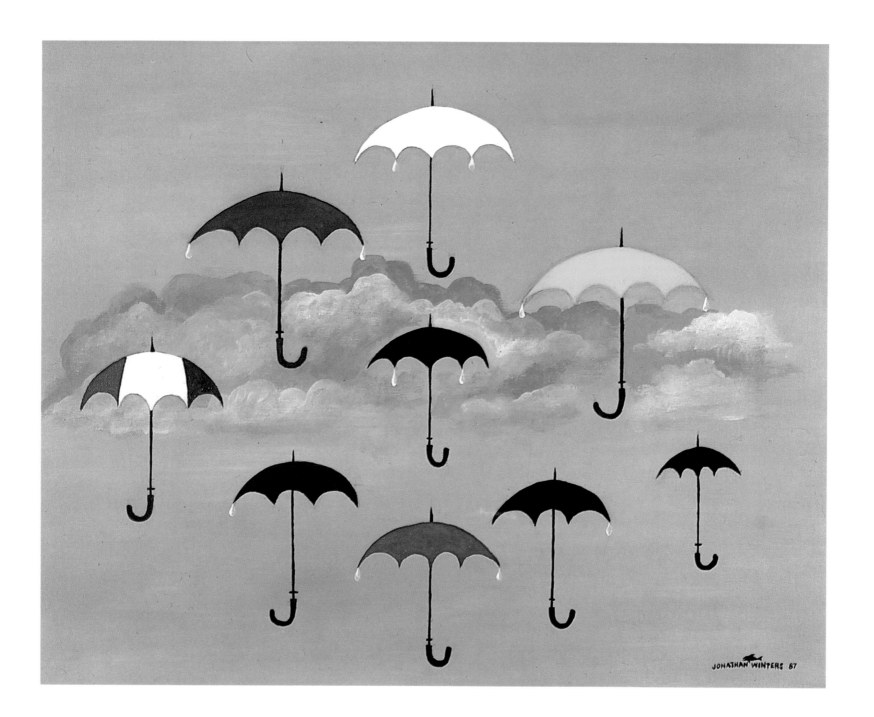

Heartland

The Middle West is the heartland. Kansas, Nebraska, Illinois–all the sheaves of wheat rising endlessly mile after mile. So all I did here was take that image, and place *real* hearts in the heartland. And if you can tell me why not, I'd love to hear from you....

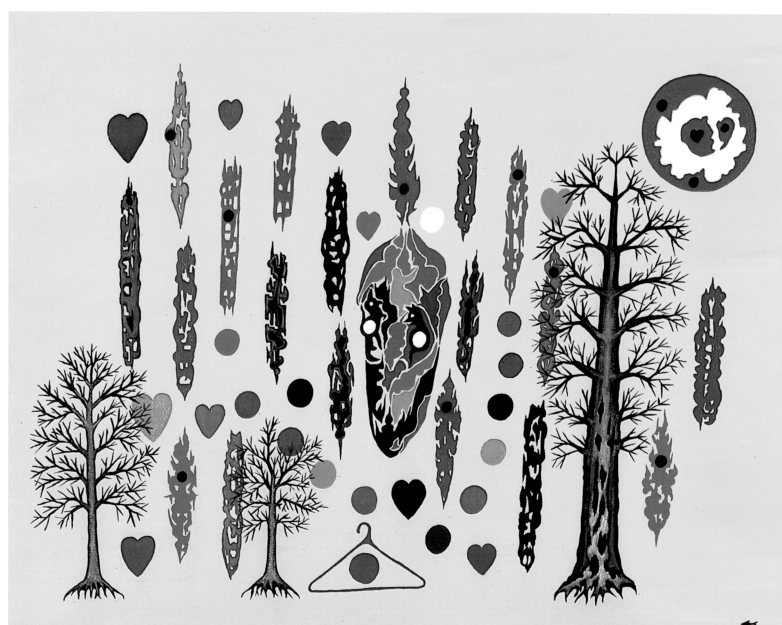

Canadian Owl

I've always had a thing about owls. They're not only wise, but from three hundred feet up, at night, they have the radar to pick up a mouse. I also have great horned owls hanging out around my house. But what really inspired this painting are the great totems, carved by the Haida, in Vancouver, British Columbia. If you get up that way, stop by Stanley Park and see them; the owls—and the totems—are unforgettable.

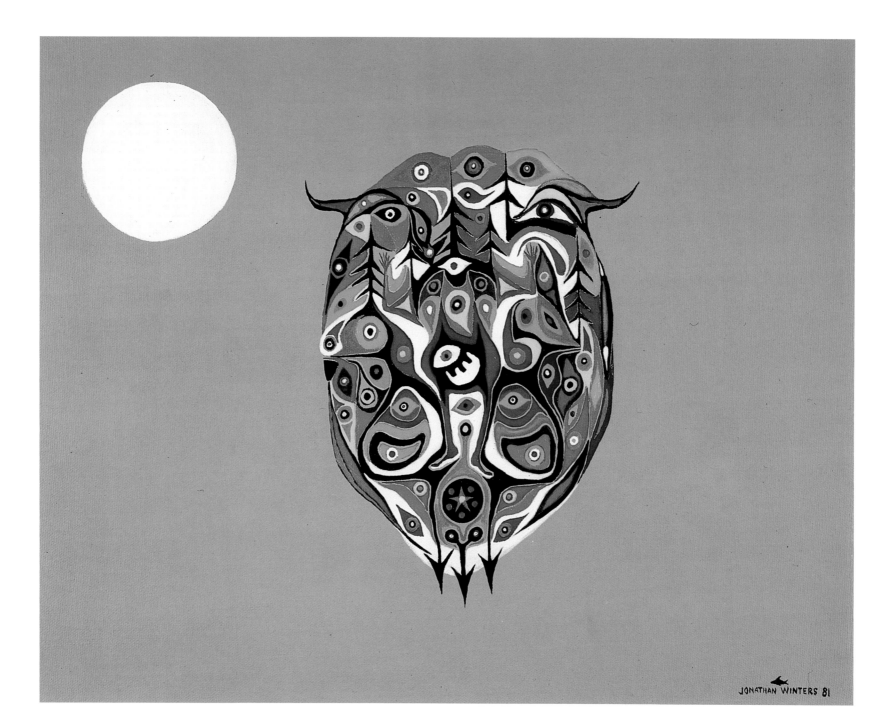

Two Dead Birds

Many birds die of cat fear. If you were the size, say, of a wren, and looked into the face of some huge Persian, you might have yourself a massive coronary. Actually, I remember my wife was a little upset with the title of the painting; "Jon," she said, "why don't you call it 'Two Sleeping Birds'?" Well, I liked mine better, and I think it pays to tell the truth.

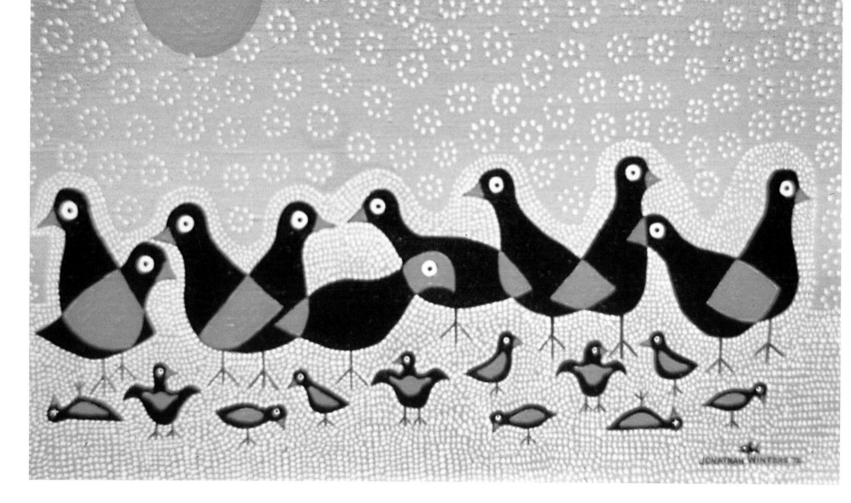

Sunday on the Other Side of the Wall

Years ago, when I first went to Berlin, I was shocked by a bombed-out church in East Berlin—and this was before The Wall went up. In this painting, this church has been taken over by the Russians, which is why I say "prey" instead of "pray." After all, whether we're preying on the Soviets or they're preying on us, someone is always preying on someone else.

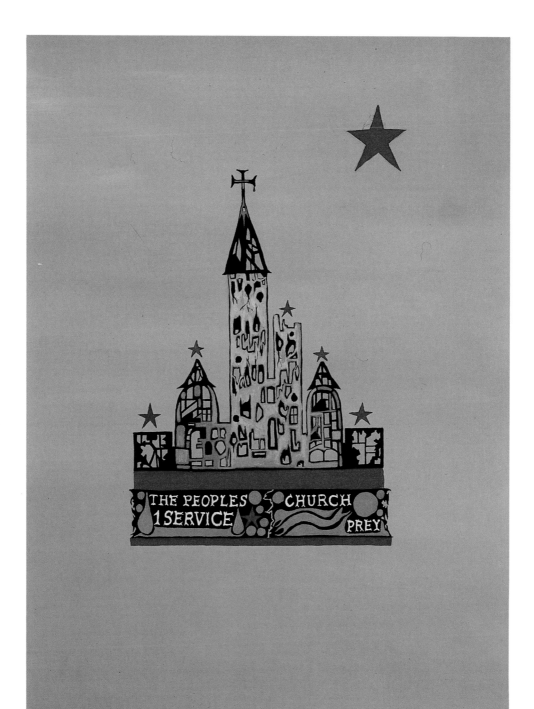

Thoughts of a Hollywood Actor While Drowning in His Pool

Although there's a lot of warmth in show business, an actor also faces a lot of rejection, a lot of hostility. You know all the old clichés like "You're only as good as your last show"—it's all true. People get stepped on or die and what's left on their grave is a copy of *Variety*. But I don't want you to think this is a depressing painting; what the Statue of Liberty is doing there is showing the freedom this business can give you, along with the hang-ups it always gives you, which is why the good lady has a hanger on her hand.

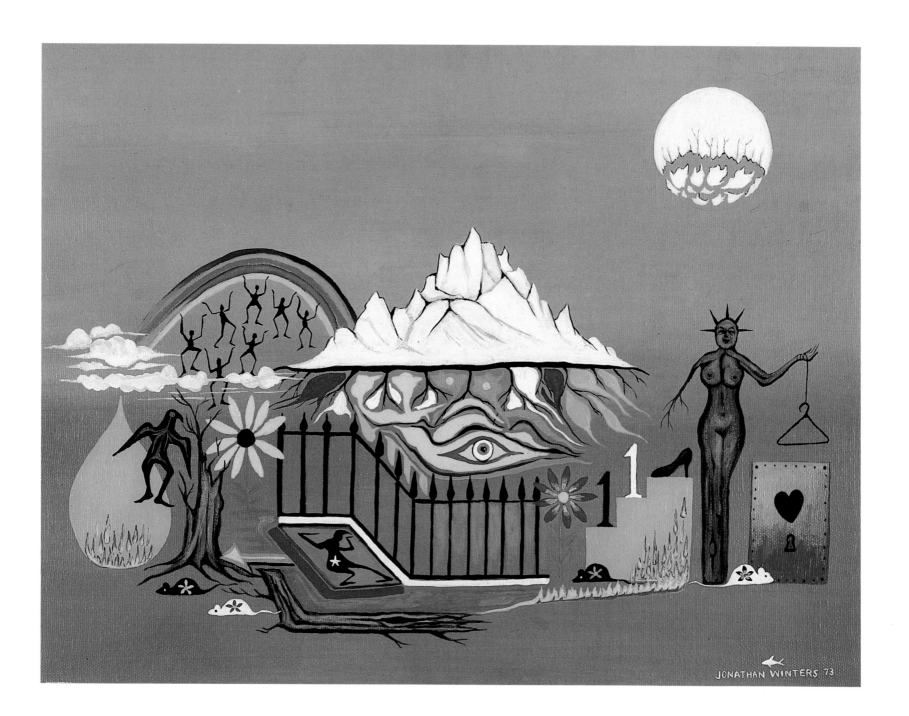

Final Approach

I'm not the greatest flyer in the world, something of a white knuckler, so I always heave a sigh of relief when I know that the wheels are down. The painting depicts an aircraft about to land, but as here, now and then in airports, birds cross in front of the plane. And that can make life very interesting, indeed.

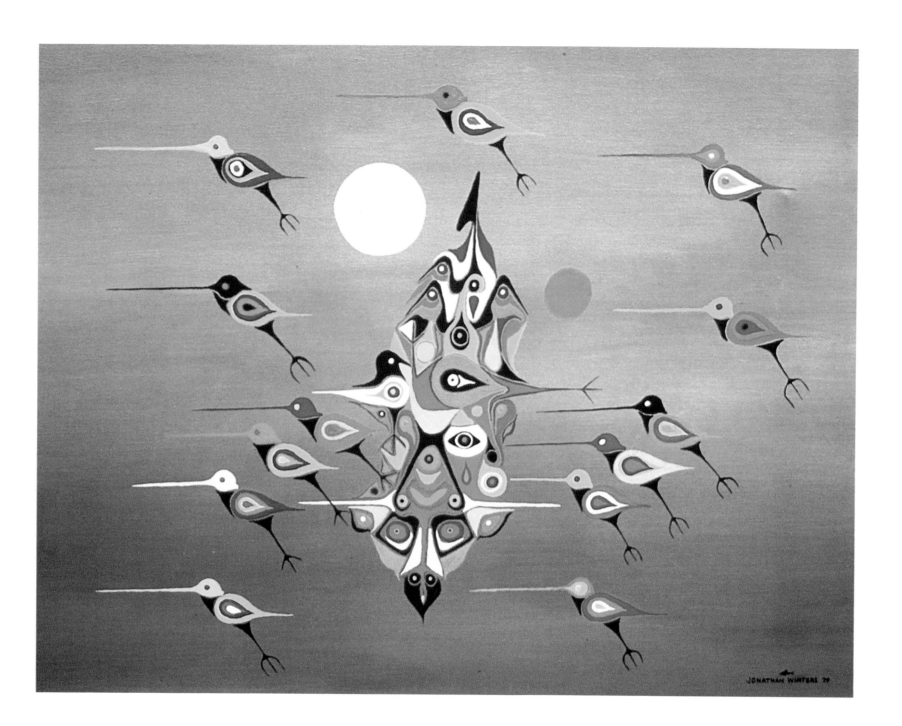

American Hooker

It's just another case of American pride. Here's this lady, working, on the streets, in a bed, an apartment, a car, and she's the best at what she does. And all I tried to do was paint everything I could think of that a hooker comes in contact with or touches. Except, of course, for the tree. Often in my paintings I incorporate dead trees, as they represent death, destruction and aging to me. Now, what that has to do with an American hooker could fill a book, but not this one.

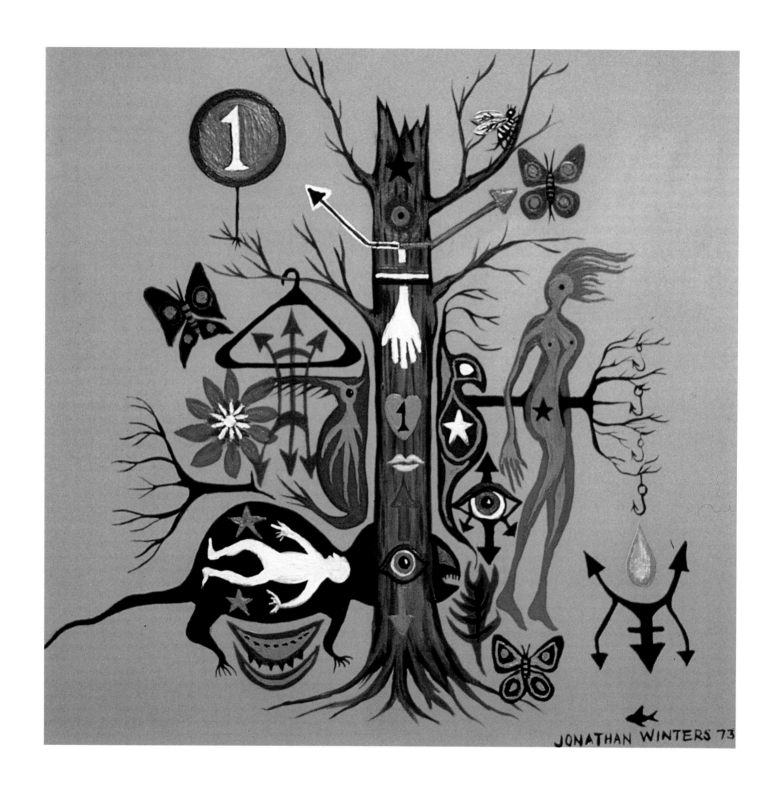

JONATHAN WINTERS '73

White Rat in the Garden

There's no heavy message here, and I don't even know for sure whether the figure is a man or a woman (or both). As for the rat, I think it's kind of good to have a rat in the garden. It thickens the plot. Anyway, the real rats are those who "steal" flowers from the garden.

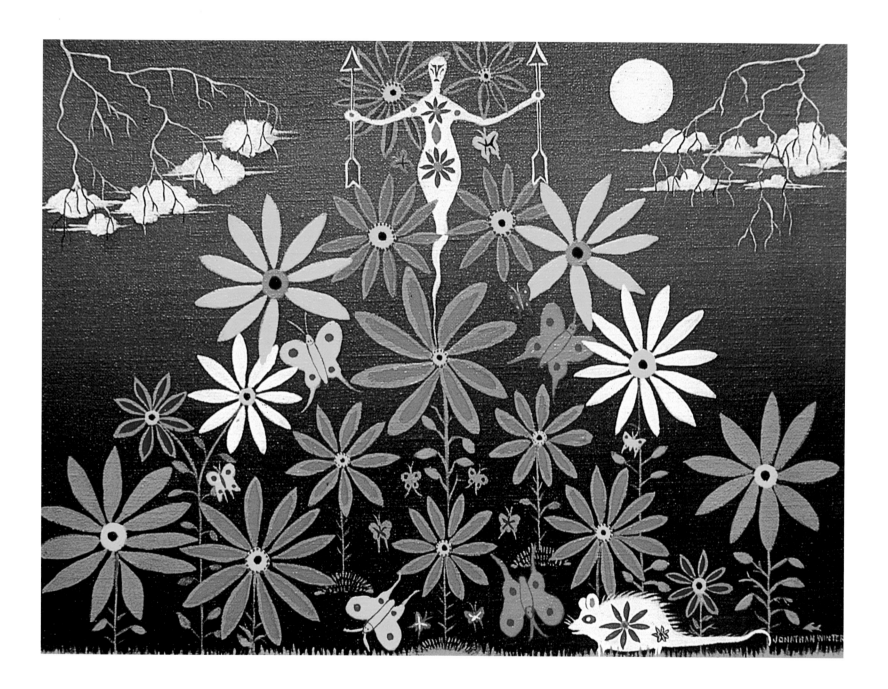

Quails on Posts

There's something, I hope, very childlike about this one. I painted it many years ago, and what's important to me is that it shows how far my work has come. As you get older, as you practice, what you need is to improve, to graduate. But simplicity, whether it's intentional or unintentional, just because you can't get any more complicated, is always appealing. In fact, I can't really remember my family ever zooming down to my studio, pointing to a painting and saying, "Oh, give me that! I want that!" No. Except for this one. When my daughter Lucinda came by and saw it, she told me she would love to have the quails, and I gladly gave the picture to her.

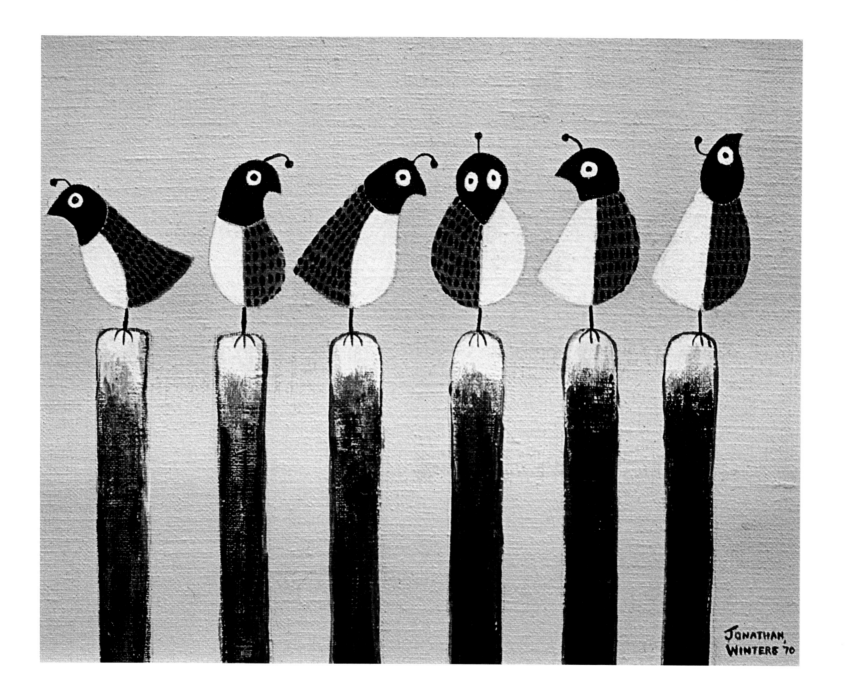

House Full of Old Gumballs

I hope everyone still takes the time to pull a penny out of his pocket and find himself an old-fashioned gumball machine. Even if the gumballs are as old (or old-fashioned) as the machine, it's still fun. As for this painting, it's just what it says it is. Actually, when I first showed this painting to my wife, she said, "Jon, it's unbalanced!" And I said, "Well, I'm unbalanced, too."

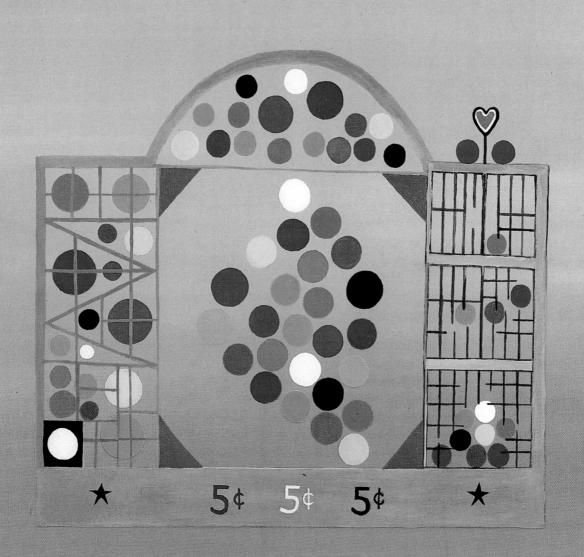

In Lieu of a Carrot

This was a bit of an experiment. I tried to combine Surrealism with the colors and feelings of American Indian art—with a little medieval chivalry thrown in for good measure. The knight is tilting that hanger in front of his horse, and the eye in the hanger is watching absolutely everything. Because, as ever, there's so much to see.

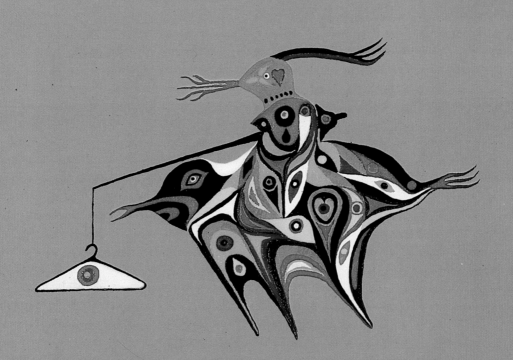

JONATHAN WINTERS 82

Fake Plague

Polio was a plague. Cancer is a plague. AIDS is a plague. And people hurt, and people die. Now, I thought this black canvas, representing the black plague, especially using the rats, would be about as strong a statement as I could make about plagues and their horrors. But then I felt compelled to lighten it up somehow. To show hope. Which is why one of the rats has a key in its back; that is really a *fake* rat, and so maybe a *fake* plague. And one of these days, I pray, the plagues might be just that–fake.

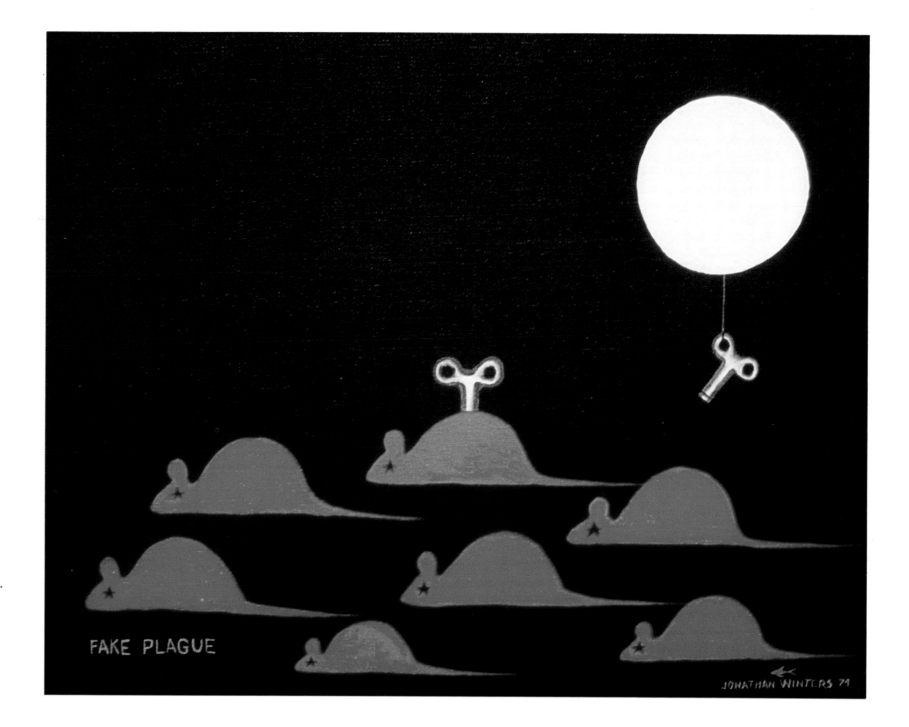

Two Birds Watching Doris Day's Cat and Dog Drown

A lot of people out here in the show business community are involved in causes favoring the protection and care of animals. It's something I feel deeply about, and I've been very involved with conservation groups, especially those overseen by my old friend Cleveland Amory. Another celebrity who has given greatly to these charities is Doris Day. Now, this painting actually has nothing to do with Doris Day at all. When I made this–the dog and cat drowning, the birds watching–I just thought to myself, *What if this happened in Doris Day's pool?* I guess it was just a bit of my black comedy at work. No harm intended.

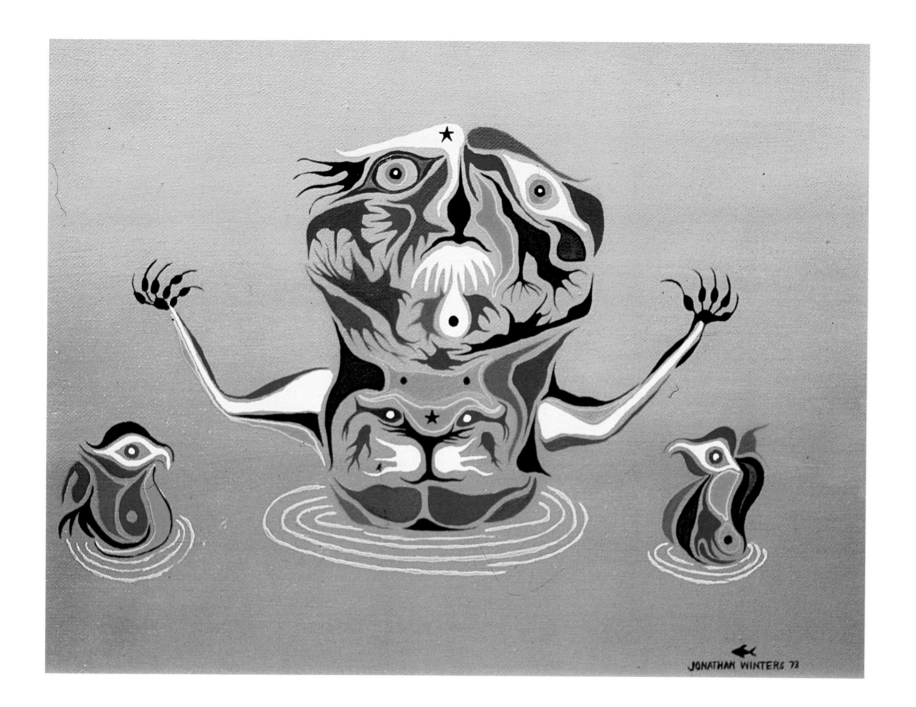

Red Bird with a Key in His Back

This was the one and only Christmas card I've ever done and it was absolutely a lot of fun to make. As for the key, it just means one of the birds is fake or a toy. Or maybe even an outsider. Besides, you'll have to admit whether it's a red bird or not, whatever birds there are under the Christmas tree usually have keys on them.

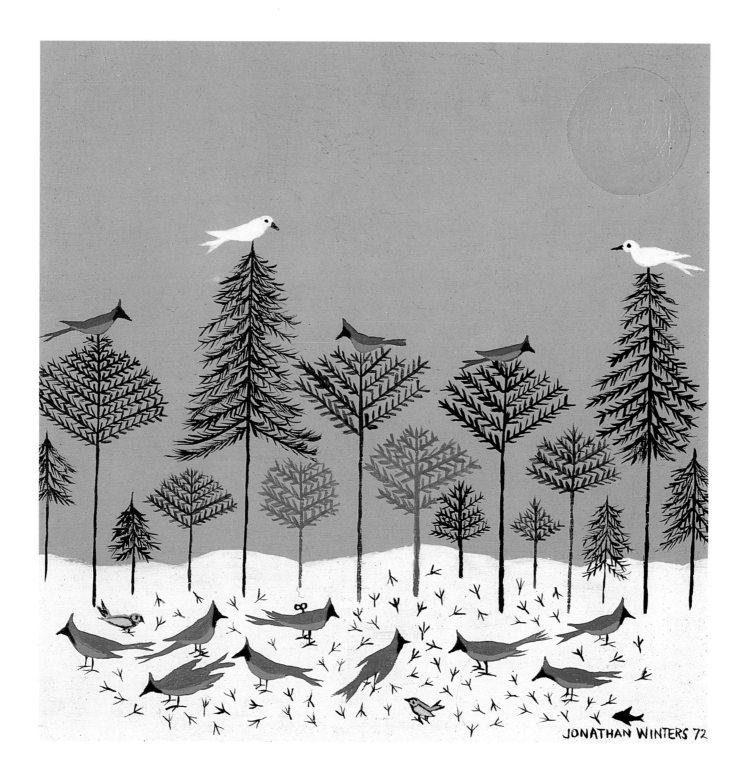

The Flaming Frog

I hate to admit it but I love to eat frogs' legs. Anytime I can get them. But I don't get them too often, so the frogs aren't in a lot of trouble.

It probably sounds hypocritical, but I'm honestly fascinated with frogs—off the plate, too. When I was a little kid, I'd take a flashlight and a jug, go out at night to the pond and catch as many as I could. Just to look at them or maybe because they were so creepy. Sometime I'll write a spooky movie scene where the hero goes out at night and all he hears is "Ribbut, Ribbut" louder and louder as he strolls along the darkness with his Coleman lantern out in the haunted woods. And then, all of the sudden——

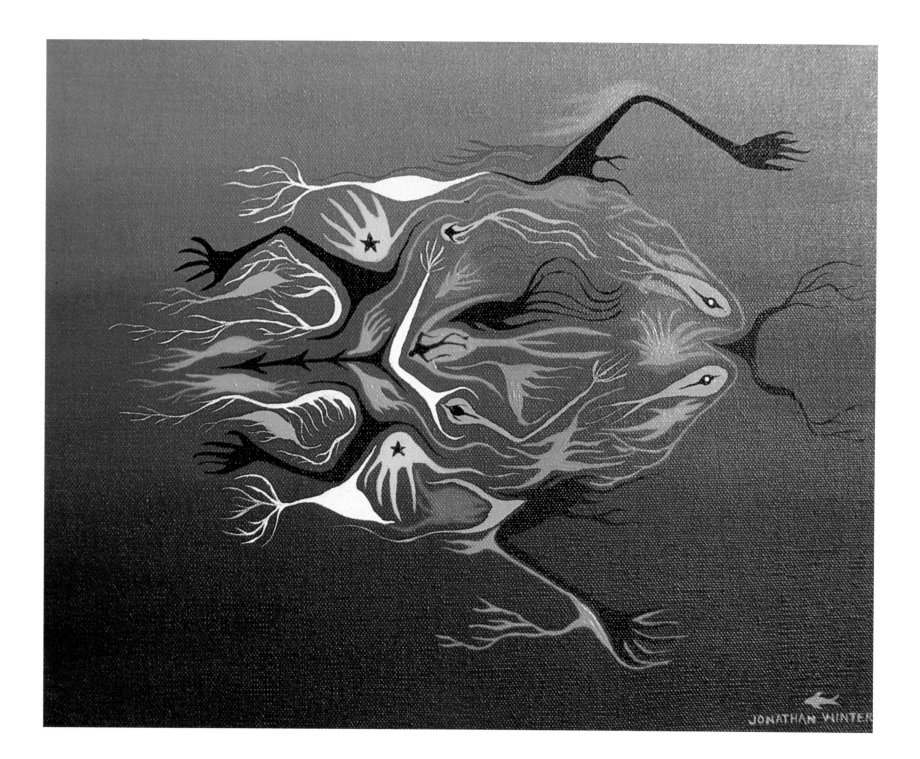

A Tree in South Boston

To put it mildly, it's been rather tough for blacks in South Boston. And that blackbird is sitting there by himself for a reason. Considering that the tree is crimson, bloody crimson, well that's the color you'll see whenever there's a confrontation between the majority and minorities. It's not necessary, but it's always going on.

I guess there are a lot of isolated figures in my paintings, which has to do with my often being isolated. On purpose. I don't feel sorry for myself, as I think we're *all* isolated sometimes and it *does* pay off. I couldn't stay alone forever, but crowds have always scared me and still do. Don't misunderstand, I wouldn't turn down box seats for a Cincinnati Reds game or a ticket on the 50-yard line for the Rams, but I guess sports are different. What I'm amazed at are all the young people who go to rock concerts and are very happy to be part of a mob scene. I sometimes think they bring comfortable things with them aside from the seat cushions. But that would be a little tough for me.

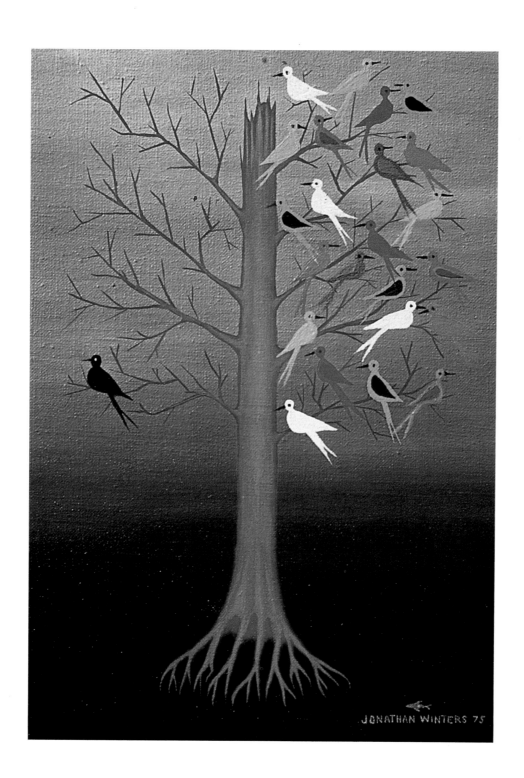

American Circus

The only sad thing about the circus is that it's changed. Back in Springfield, Ohio, with all its 68,000 people when I was a boy, we'd wake up at four in the morning to see the circus parade through town; it was the big event of the year. Nowadays, kids don't get to see this. Everything's gotten so big, so commercial with the big arenas, that the pleasures get lost. Except mayby for the clowns. They're always wonderful, and I treasure them. One of my proudest possessions is a check signed by the late Emmett Kelly of Ringling Brothers, one of the great clowns of all time. (By the time I acquired it the check had already been cashed, but for once I didn't mind.)

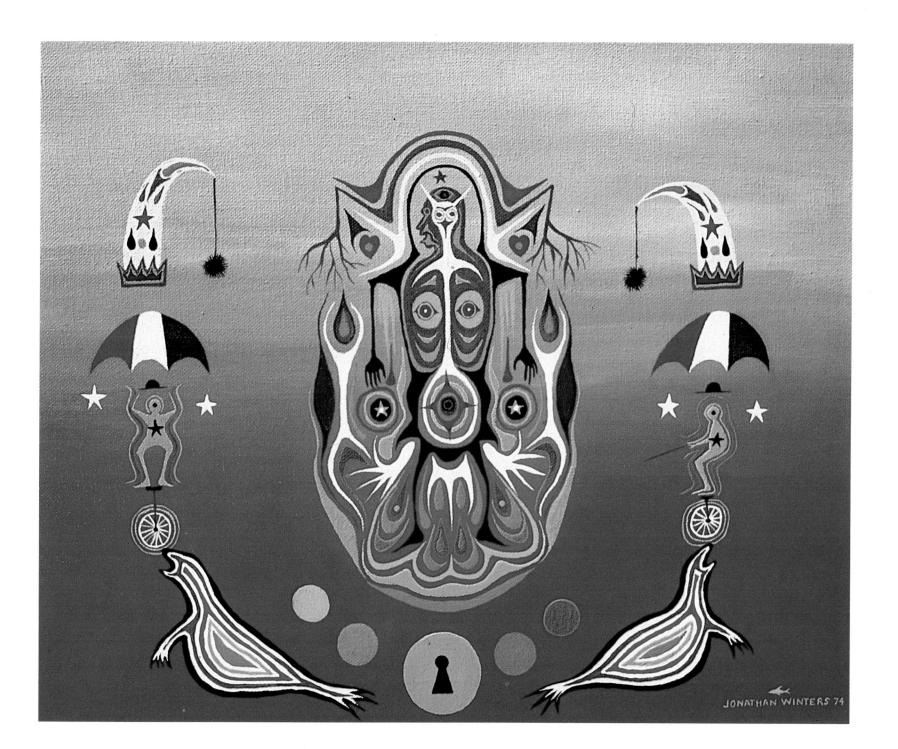

Expectant Mothers

Inside each bird there's a little bird. But what's not in this painting are any father birds. I kind of wonder where they are. I hope, in their defense, they're out building a nest or picking some berries. I hope they're being thoughtful. (They better be.)

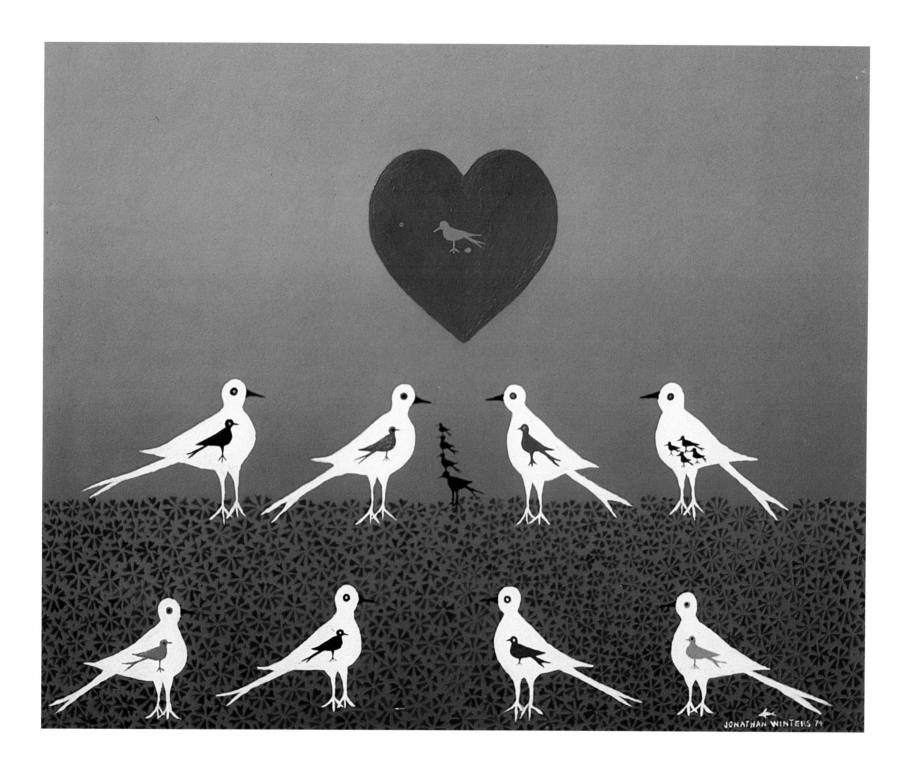

Even Big Guys Have Hang-ups

One time I was in Japan taping a television special. We all took a trip to Osaka, and went to see a sumo wrestling match. Now, here are these tremendous guys, 375 or 400 pounds–I mean huge–fighting each other. I kept wondering, How in God's name can they do it? How can they move, let alone maneuver the way they do? And it just gave me the idea for this painting: Big, big men ready to take you on–hang-ups and all.

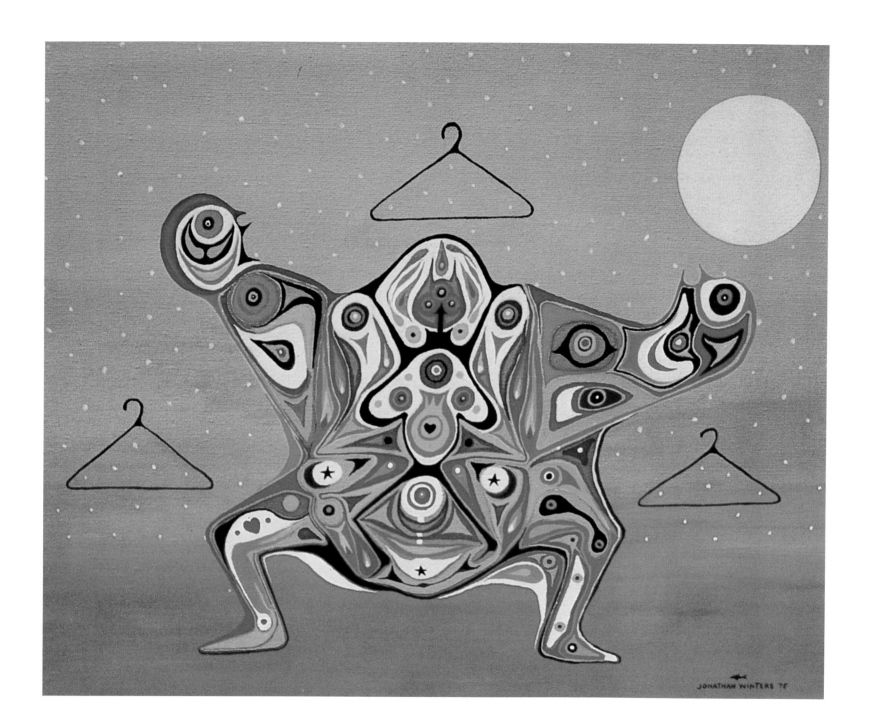

City Dump

With paintings, I think it's important to read into them whatever you want to read into them. Make up your own interpretation, your own reaction, whatever meaning suits you best. And then not worry whether you're right or wrong. Because there isn't any right or wrong anyway. At least about paintings. As for this canvas, every town, big or small, does have a city dump. And as unattractive as the dumps are, now and then, you do come across some neat things to take home.

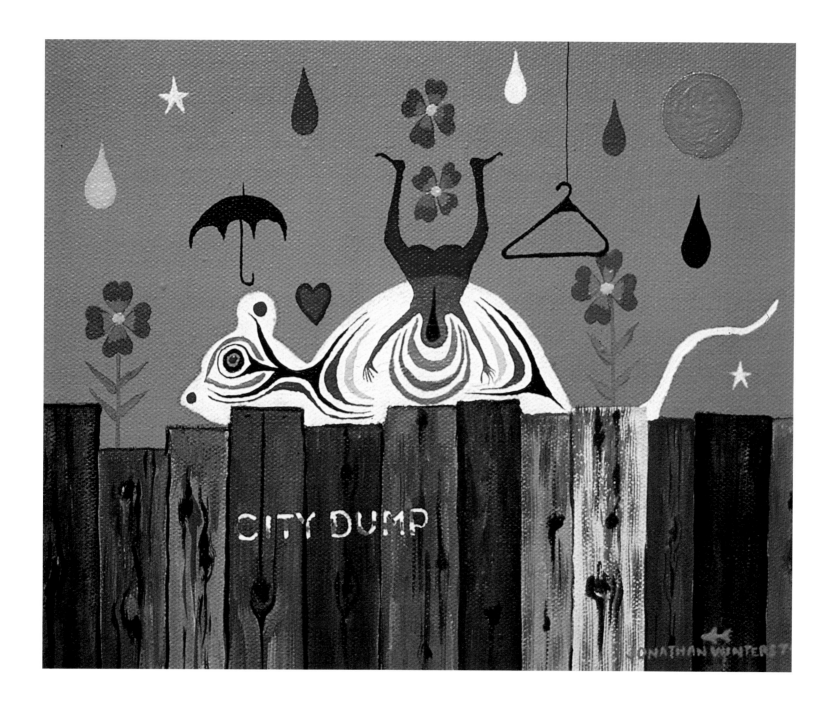

American Roots

Again, this one is very Indian-influenced. As for the black egg, with the bird, to me that represents life eventually returning and going on. One hopes.

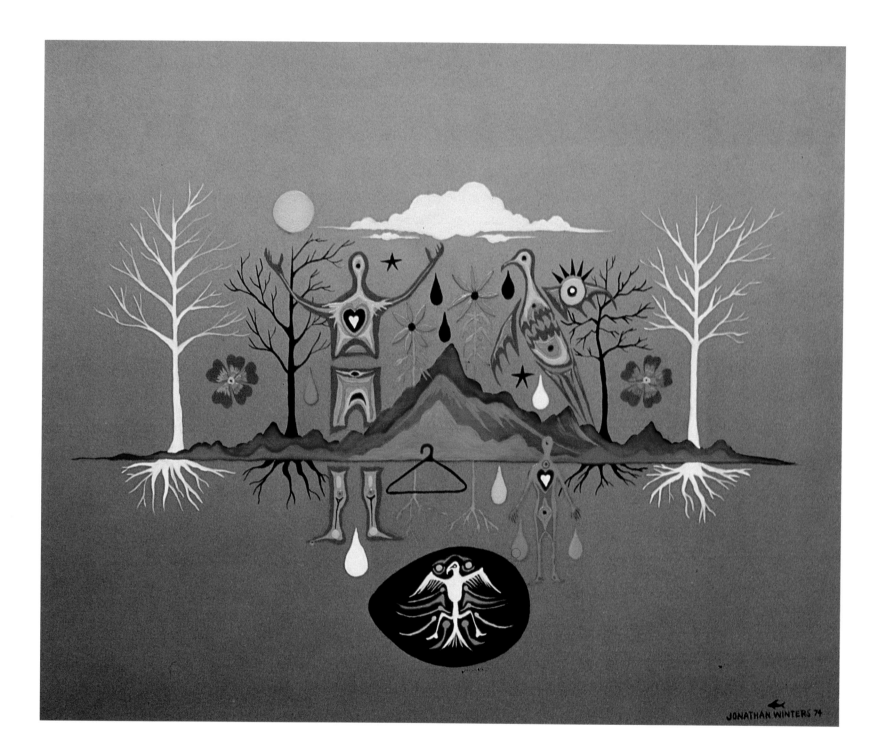

The Last Day of California

I've lived out here for twenty-five years now, and have made it through a couple of quakes. In the worst one the house shook and it felt as if a thousand elephants were going through the living room. It's a sensation you never forget. The funny thing, though, is what happened the next night. I had to appear at a convention for a beer company and there was an aftershock. All of a sudden the chandeliers started swinging back and forth. And everyone thought it was just the beer.

Anyway, Californians are always waiting for The Big One. It's the only thing they can do.

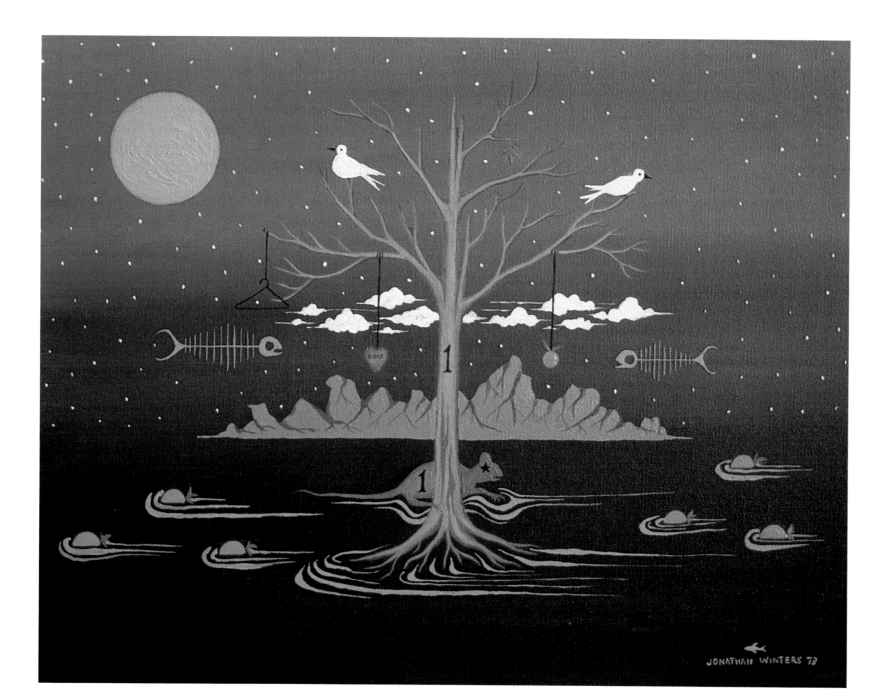

Hung Up on Strange Fruit

Well, we're all hung up on something, right? So why not get hung up on strange fruit–especially apples. The hangers, I thought, would be an appropriate symbol–or symbols.

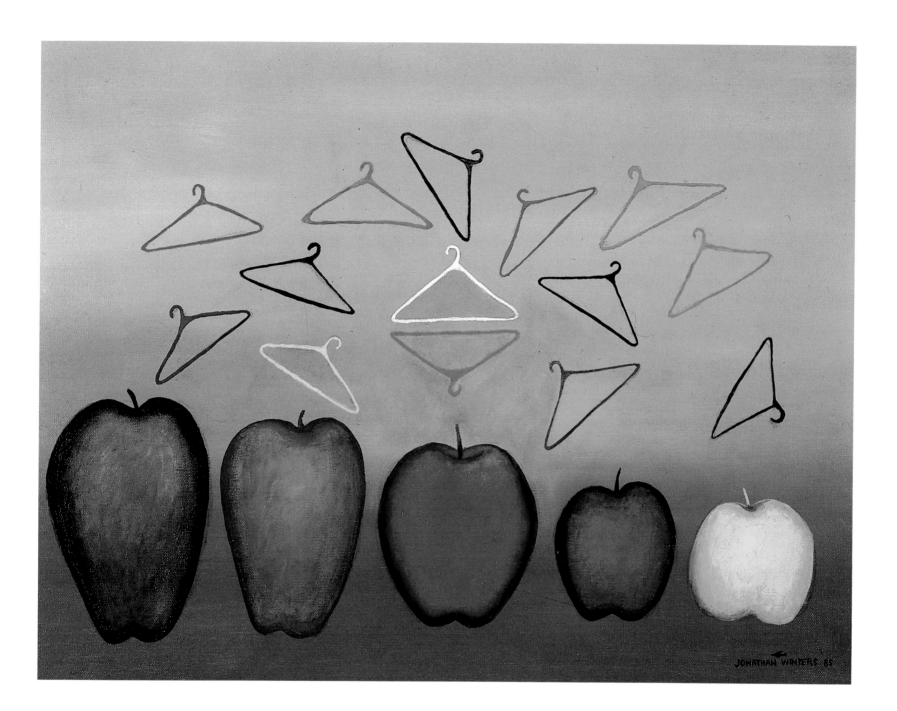

Watering the Flowers

I have no green thumb. No green forefinger. In fact my fingers are entirely flesh-colored. But I love flowers, and I've been lucky because my wife has always made sure our house is surrounded by them. As for the rat, well, there's always one somewhere. Now, I confess rats are a little tough to take, so I've put a red heart on this one, just to tone him down.

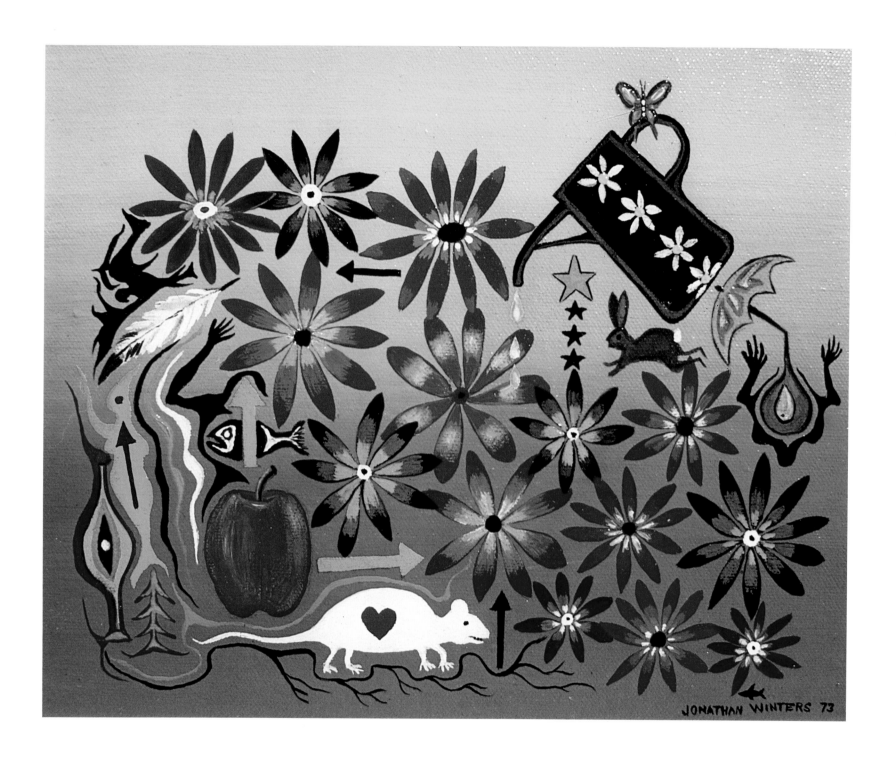

JONATHAN WINTERS 73

The First and Last Day of Spring

It's spring. And there're all these little homes and buildings and greenery and innocence. And everyone is thinking it's just another day. And it's not. War rains terror. And if we continue to fight wars, it really will be the first and last day of spring.

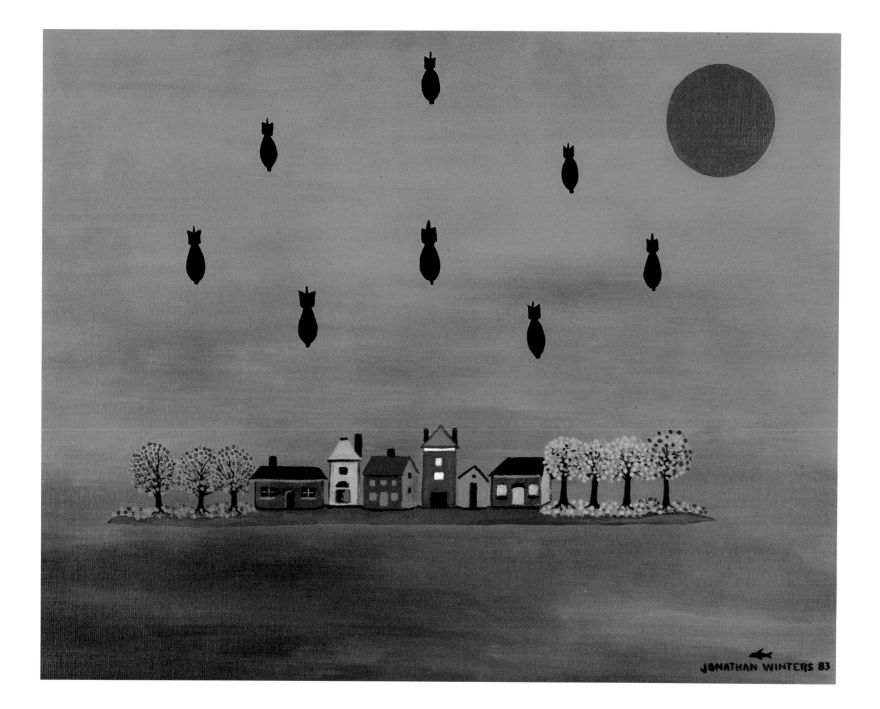

About the Author

JONATHAN WINTERS was born in Dayton, Ohio, in 1925. After serving with the marines in the South Pacific for two and a half years, he studied at Kenyon College and the Dayton Art Institute. Soon thereafter he won a local talent contest, which led to a job in 1949 as a radio disc jockey on WING in Dayton, Ohio. In 1953 Winters moved to New York and worked first in television and then in nightclubs, becoming a staple at nightclubs throughout America. Regular television appearances followed, notably on the Garry Moore and Steve Allen shows, and on Jack Paar's programs for NBC. His own TV series, *The Jonathan Winters Show,* first aired in 1956. As an actor, Winters has starred in such acclaimed films as *It's a Mad, Mad, Mad, Mad World, The Russians Are Coming, the Russians Are Coming, Oh Dad, Poor Dad,* and Tony Richardson's classic *The Loved One*, and is currently appearing in *Moon Over Parador,* which will be released in 1988. Today, he continues to make frequent television and motion picture appearances, performs solo concerts, and shows his paintings and drawings in galleries throughout the country. His collection of short stories, *Winters' Tales*, was published in 1987 and he is currently writing his autobiography. He has two grown children and lives with his wife, Eileen, in Los Angeles.